POSTCARD HISTORY SERIES

Carolina Beach

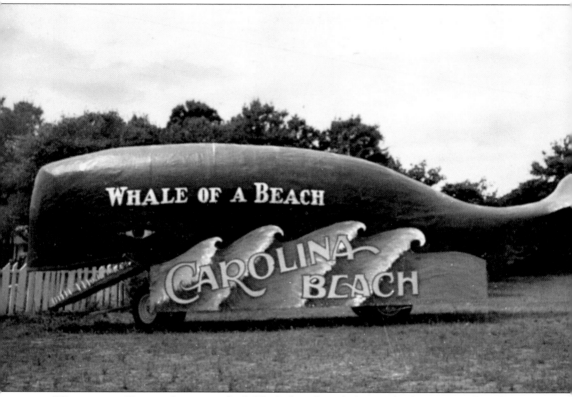

WHALE OF A BEACH. It may not look like it, but this whale on wheels was actually a float used in the Azalea Festival parades and probably others. Pretty girls were selected from the town to ride on top in bathing suits and wave to the crowds. When not in use, it was parked behind the Municipal Building across from the yacht basin for all beach visitors to see. This card was postmarked on August 23, 1954. Less than two months later, Hurricane Hazel ripped ashore and made the whale on wheels one of its many casualties. (Courtesy of Albert Jewell.)

ON THE FRONT COVER: The Landmark's welcome sign with Pepsi-Cola bottle caps looms large over the Boardwalk at Carolina Beach, North Carolina. Cliff Smith Sr. owned the Landmark and the Cornerstone Restaurant across the way. He can be seen at the Wishing Well under the Cornerstone sign. This portion of the boardwalk was at the end of Cape Fear Boulevard and was a bustling center of activity. (Courtesy of the author.)

ON THE BACK COVER: Two bathing beauties pause for the camera in this 1950s shot at Carolina Beach. On the right is Sylvia Fountain, whose grandfather, W. G. Fountain, built the Fountain Rooms and Apartments and Hotel Royal Palm in the mid-1930s. He was also mayor in the 1940s. Her friend is Mary Frances All; she and Sylvia graduated from Wilmington's New Hanover High School in 1957. (Courtesy of the author.)

POSTCARD HISTORY SERIES

Carolina Beach

Elaine Blackmon Henson

ARCADIA
PUBLISHING

Published by Arcadia Publishing
Charleston, South Carolina

Printed in the United States of America

Library of Congress Catalog Card Number: 2006938688

For all general information contact Arcadia Publishing at:
Telephone 843-853-2070
Fax 843-853-0044
E-mail sales@arcadiapublishing.com
For customer service and orders:
Toll-Free 1-888-313-2665

Visit us on the Internet at www.arcadiapublishing.com

To Skip, who is truly the wind beneath my wings, for Caroline and future generations, and in memory of Sheba.

CONTENTS

ACKNOWLEDGMENTS

I have to begin by thanking the friends who got me started on this adventure. Susan Taylor Block gave me the idea of collecting postcards to get some vintage pictures of Carolina Beach and thereby planting seeds of a history quest. She also recommended me to Arcadia Publishing to do this book. Beverly Tetterton encouraged and helped me with the postcard collecting, taught me how to do research, and has been an invaluable resource. Ann Hutteman edited the text and did my bibliography and index. Her postcard book of Wilmington was a wonderful example to follow. Without the vast collection of newspaper clippings in the Bill Reaves Files at the New Hanover County Public Library's North Carolina Room, this project would not have been possible. The Federal Point Historical Preservation Society was very supportive, especially Leslie and Darlene Bright, who helped with proofreading and contributed their vast knowledge of Federal Point, advice, and proofreading. Diane Cashman was always in the wings when I needed her. My editor, Maggie Bullwinkel, at Arcadia Publishing listened, advised, encouraged, and supported me every step of the way. I have interviewed and talked to many people; many have also loaned precious family images and postcards to me for use in this book. I am deeply indebted to Bill Auld, Andy Canoutas, Jennie Kure Robertson Bagley, Doris Bame, Dennis Barbour, Lynn and Jimmy Benson, Gil Burnett, Wayne Bowman, Ann Plummer Corr, Eddie Capel, Frances and Bob Doetsch, Kendall and Gary Doetsch, Dr. Chris Fonvielle, Carol Sessoms Ford, Griff Fountain, Jim Fountain, Charles "Tommy" Green, Albert Jewell, Rachel Johnson, Willard Killough III, Lank and Genie Lancaster, Mildred and Malcolm McIver, Jasmine McKee, Dr. Byron and Judy Cumber Moore, Norm Melton, Earl Page, Allen Pennington, Nancy Adams Potts, Mike Robertson, Lynda McIver Whitted, Capt. Skippy Winner, and Edward Worrell. A special thanks to my friend Mary Kathryn and her prayers to St. Anthony, the patron saint of lost causes and sometimes photographs. A special thanks also to Fran Doetsch, who never gave up looking. And lastly, thanks to my family and friends who were always there for me, especially my children, Tyler and Meg, and my husband, Skip.

INTRODUCTION

For more than a century, beachgoers, boaters, and fishermen have been coming to the shores of the Atlantic Ocean at Carolina Beach. Located on a peninsula known as Federal Point, the beach sits near Wilmington, North Carolina. The peninsula became an island when the Intracoastal Waterway was completed with the digging of Snow's Cut in 1931. Part of the cut followed the natural course of a creek named Telfair's Creek.

The history of Federal Point goes back to Colonial America. On July 14, 1725, the Lords Proprietors granted to Maurice Moore a vast amount of land of which Federal Point was a part. After a succession of owners, a portion of the land was purchased by James Telfair, for which Telfair's Creek was named. By 1817, the federal government had built a lighthouse near the southern tip of Federal Point. The Burriss, Craig, and Newton families were among those who lived in this sparsely populated area. For the most part, they were farmers and Cape Fear River pilots. The mid-1800s brought the Civil War and the building of Fort Fisher, where hundreds of Union and Confederate soldiers lost their lives.

The 1860 census listed 72 households on Federal Point; 8 of those were listed as "colored" or "mulatto." Alexander and Charity Freeman were one of those latter households. This family would later play an integral role in the history of Carolina Beach. No one knows exactly when these freed slaves settled near Myrtle Grove Sound or which plantation or owner freed them. What is known is that in 1855 they bought 99 acres of land next to the sound, and by Alexander's death, they had also acquired 180 acres at the head of Myrtle Grove Sound. The land was inherited by their son, Robert Bruce Freeman and he parlayed his investment to become one of the largest landowners in the county. In 1876, Freeman and his wife, Catherine, purchased large tracts of land totaling 2,500 acres from the Cape Fear River to the Atlantic Ocean, including Gander Hall Plantation and Sedgeley Abbey Plantation, which they renamed Old Homestead. The purchase was a cash sale, as no mortgage or deed of trust was recorded. They also made two major donations of land from these tracts: one was 10 acres to St. Stephens AME Church in Wilmington to use as a campground near the Cape Fear River and the other was for a school. In 1877, the public school for colored children at Federal Point had 34 pupils led by teacher Charles M. Epps.

In 1879, the Army Corps of Engineers completed the closing of New Inlet from Fort Fisher across to Zeke's Island after several years and thousands of man-hours. The inlet had been created by a severe hurricane in 1761 and posed a serious navigation problem of shifting shoals between it and the Cape Fear River Inlet. This project, along with notoriety of this area for its role in the Civil War, intrigued people who wanted to see it for themselves. Capt. John W.

Harper was already taking passengers past Fort Fisher on trips to Smithville, now Southport, on the steamer *Passport*. In 1880, he began making stops to see the New Inlet Dam, which he nicknamed "The Rocks." Some of the sightseers on those trips were fishermen. They organized the Fort Fisher Fishing Club and built a clubhouse there in 1882. The next year, Harper was taking moonlight excursions there with sheephead suppers at Mayo's Place included in the 50¢ round-trip price. By 1884, the *Wilmington Star* advertised two cottages for rent at the Rocks "where steamers go daily."

It is said that Joseph Lloyd Winner, a Wilmington jeweler by way of Pennsylvania, liked to take these steamer trips. Once he got off near Sugar Loaf on the Cape Fear River and walked past Gander Hall and the head of Myrtle Grove Sound on his way to the sea beach. He and his wife, Anna, decided to buy a large tract from James T. Burris in December 1880. The tract was bordered on the east by Myrtle Grove Sound. Here he laid out streets and named it the town of St. Joseph. It failed to prosper because of its remote location and lack of adequate transportation, but St. Joseph Street and Winner's descendents remain to this day.

Seeing the potential, Captain Harper, William L. Smith, and some other associates formed the New Hanover Transit Company in 1886. After purchasing a right-of-way from the Winners to build a railroad, Smith purchased a 24-acre strip of land from Robert Bruce Freeman for $66.50. That strip is essentially the north end of Carolina Beach today. They began building the railway in January 1887, and by June, passengers were cruising down river on the *Passport* to Federal Point and landing at a pier near Sugar Loaf. From there, they boarded the little train later nicknamed the "Shoo Fly" for the two-mile ride over to the beach. That first summer, most excursionists came for the day, using the facilities of the new pavilion. Those who wanted to stay over lodged at Bryan's Oceanic Hotel and ate meals at the Railroad Station Restaurant, both barely completed. The new resort proved so popular that summer of 1887 that the 350-passenger *Passport* pulled a 150-passenger barge to accommodate the throngs.

For the 1888 season, Captain Harper purchased a steamer, *Sylvan Grove*, which was licensed to carry 600 passengers. It had three decks enclosed with white railings and had salons on the main and promenade decks. Lewis Philip Hall wrote in *Land of the Golden River, Volume One* that the ladies' salon "glittered and sparkled with many mirrors." On July 4, 1888, the new steamer made two trips, bringing over 800 excursionists who bathed in the surf, looked for seashells, or took hack (open carriage) rides from Battery Gatlin past blockade runner wrecks to Fort Fisher. They also enjoyed two new bathhouses, had cool, fresh well water to drink, and saw Captain Burris's fishing boats come in through the breakers full of fish. That evening, Captain Harper had fireworks on the bow of the steamer to cap off the Independence Day activities.

In 1889, New Hanover Transit Company moved the river pier from Sugar Loaf to Doctor's Point, often called Caintuck Landing. The new location, which was north of Telfair's Creek, provided a deeper water landing for the new and larger steamer. This move made it necessary to lengthen the railroad by a mile. That season also brought the construction of a windmill, water reservoir, and new cottages to make a total of 15.

Nineteen more cottages were built during the season of 1890, making 34 all together, with building lots selling for $1 a foot. That winter, the *Sylvan Grove* was at its winter berth on the west bank of the Cape Fear River near Eagle's Island and across river from the foot of Nun Street in Wilmington. A fire of unknown origin burned it to the water line.

The loss of the *Sylvan Grove* took Captain Harper in search of a new steamer, which he found in Wilmington, Delaware, in 1891. Already named the *Wilmington*, he proudly sailed it down river to Carolina Beach for the first time on April 29 of that year. That same summer, Hans A. Kure opened a billiard hall, 10-pin alley, and a family grocery at the resort. A few years later, he brought to the beach a riding gallery, or "hobby horses," that had been operating at Sixth and Campbell Streets in Wilmington. About that time, horseback riding was added to the ever-growing list of amusements to be enjoyed at the beach.

The next few summers, additional steamers assisted the ferrying of excursionists on the *Wilmington*. They were the *Clarence, Murchison, Italian,* and *Lillie*. Games of baseball at the beach

became very popular, and the sport sprouted many teams. Two private beach clubs also opened in the 1898 season: Sedgeley Hall Club on May 27 and Hanover Seaside Club on July 8. They were both spacious, two-story buildings with 12-to-20-foot-wide wraparound porches and separate bathhouses for men and women. The subscribers of these clubs could telephone home since a line was put up that same year.

The early 1900s brought new happenings. A fire destroyed the pavilion, Kure's Bathhouse, and Smith Cottage in 1910. That tragedy paved the way for a grand new pavilion, designed by Henry E. Bonitz, which opened the following year. In 1912, A. W. Pate and some associates bought the New Hanover Transit Company. In 1913, they added 772 acres purchased from Bruce Freeman to their holdings. The year after that, they installed an electric power plant (see map on page 29). By this time, Carolina Beach was well on its way into the 20th century and becoming the resort well-known today.

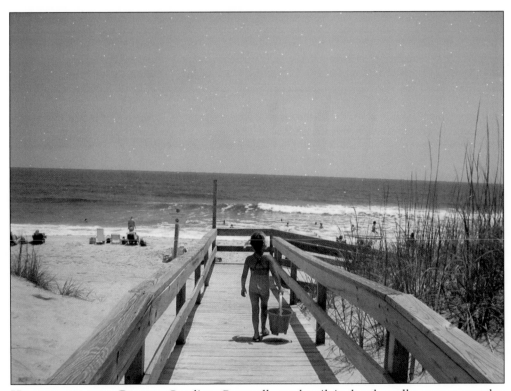

HEADED TO THE BEACH. Caroline Gemmell, sand pail in hand, walks over a wooden boardwalk to the white sands and sparkling Atlantic. The year 2007 marks 120 years since the first children came with their parents to Carolina Beach as a resort in 1887.

NOTES ON POSTCARDS

The latter part of the 1800s brought the invention of the telegraph and telephone, but writing remained the way most people communicated. With exquisite penmanship, beautiful papers, and sealing wax, letter writing was a true art. There were those who wanted a briefer and more casual form of letter, and that is probably how postcards came to be.

The first ones were seen around 1850 and evolved through several stages. Since the postcards in this book fall into five of those stages, this explanation will focus on them.

Undivided Back, 1901–1907. The federal government allowed for the word "Post Card" (either one word or two) printed on the backs of these cards with beautifully lithographed fronts done in Europe, mainly Germany. The entire back was reserved for the address, so the writer either wrote no message at all or a very brief one on the front on top of the picture. The card titled "Lifeline" on the bottom of page 21 is an example of this type of early card.

Divided Back, 1907–1915. As the name implies, the backs of these cards were divided; the address went on the right and a message on the left. Still from Germany, World War I brought this era to an end. "Fun for the Kiddies" on page 22 is an example.

White Border, 1915–1930. Printed in the United States, cards from this time had a white border all around the image to save ink. All the cards on pages 23, 24, and 25 fall into this category.

Linen, 1930–1945. Due to the high rag content, these cards were printed with a linen-like finish; bright colors prevailed and the "large letter" cards in chapter one also came into fashion. "Airport" on page 31 is a good example as are half of the cards in this book.

Photochrome or Chrome, 1939–present. These cards are photographs and are usually printed with a glossy finish. "City Hall and Fire Department" on page 35 is an early chrome card.

Postcard collecting, also known as deltiology, is the third-largest hobby in the world, with coin and stamp collecting holding the first and second positions. The U.S. Postal Service records listed 677,777,798 cards mailed in the fiscal year ending 1908, when the population was only 88,700,000.

Unless otherwise noted, all of the postcards in this book are from the author's collection.

One

GREETINGS FROM

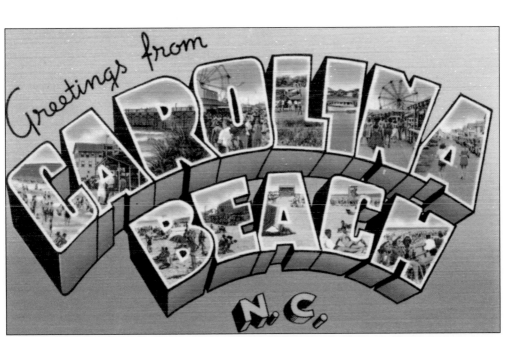

GREETINGS FROM, LARGE LETTER. During the 1930s and 1940s, "large letter" postcards became very popular. The name was spelled out with views of a particular town or state inside large three-dimensional letters. The large letters were usually preceded with the words "Greetings from." The early ones had plain backgrounds like this one.

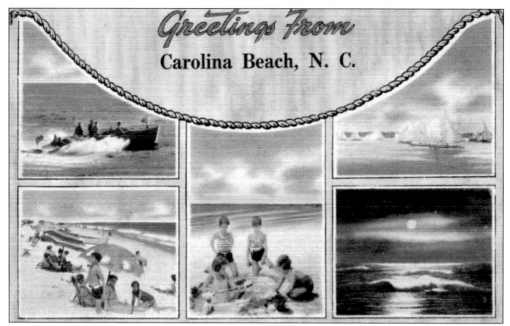

ENVELOPE CARD. A nautical rope forms a flap on this linen card to make it look like an envelope. The pictures depict boats, the beach, and the ocean, all scenes waiting for visitors in Carolina Beach. The space for the stamp on the back says that a 1¢ stamp is required, earning cards from this era the nickname "penny postcards."

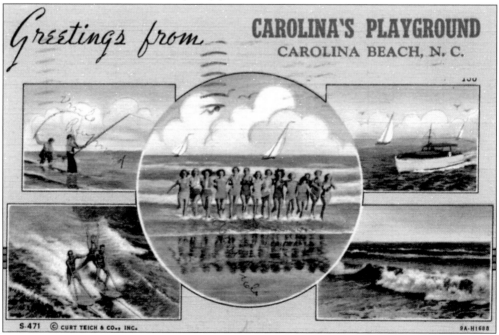

CAROLINA'S PLAYGROUND. An aunt and uncle sent this card to their young nephew in Granite Quarry, North Carolina, during the summer of 1945. They personalized the front by writing their names on the pictures. Over the fisherman on the top left is "Uncle Raymond;" under the fourth one of the girls running out of the ocean in the center is "Aunt Viola."

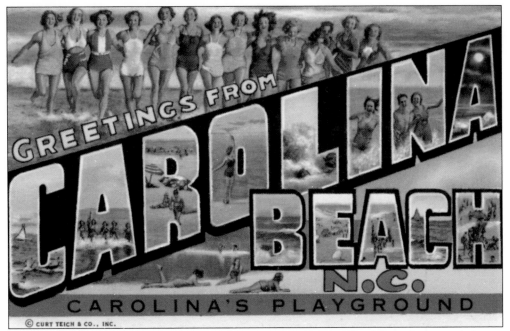

CAROLINA'S PLAYGROUND. By the mid-1940s, the backgrounds of large letter cards began to fill up with pictures, adding to those inside the letters. A special Carolina Beach edition of *Wilmington Evening Post* announcing the formal opening of the 1946 beach season stated that 500,000 postcards of beach scenes were sold there last season.

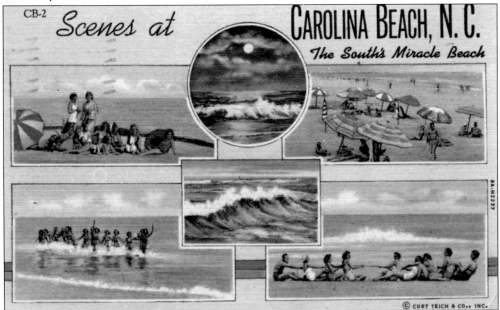

SCENES AT The phrase "Carolina Beach, The South's Miracle Beach" is often found on cards after the devastating boardwalk fire on September 19, 1940. The fact that they were able to rebuild over two blocks from ashes and rubble before the 1941 beach season was truly a miracle. The town was proud enough to make it a slogan for many years afterward. This card was postmarked in 1951.

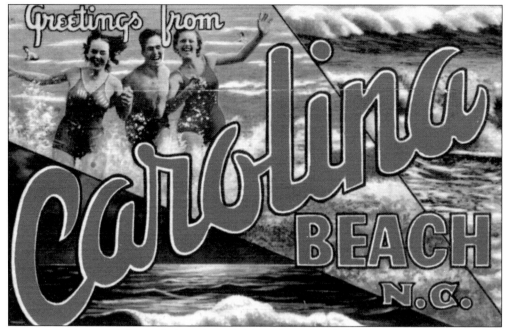

SOUVENIR FOLDER. The card above has solid large letters with the pictures in the background divided into triangles with art deco flair. It is not really a card, but the front of a souvenir folder of several scenes, including the boardwalk, the Atlantic Ocean under a full moon, the beach, surf fishing, the Fresh Water Lake, and lots of bathing beauties. Below is the back of the folder with a beauty on an inflatable rubber horse. At the bottom it says, "The South's Miracle Beach." It was mailed to Kannapolis, North Carolina, on August 1, 1947, and required two 1¢ stamps.

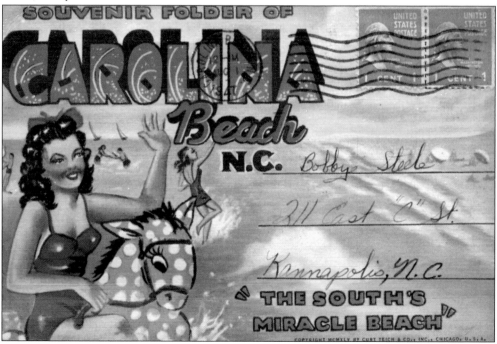

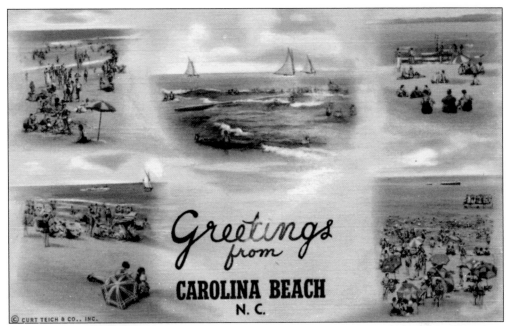

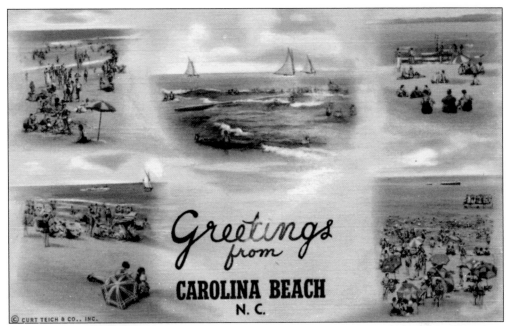

MULTIPLE SCENES. Most of the multi-scene cards were manufactured by Curt Teich and Company from Chicago. Teich emigrated from Germany and started the company bearing his name in 1898. He became world famous for the linen, large letter postcards from the mid-1930s to late 1950s. The company continued to operate until 1978.

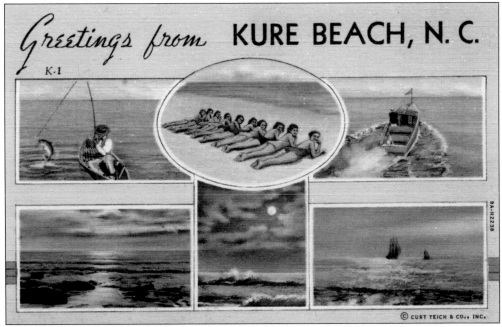

KURE BEACH, NORTH CAROLINA. Kure Beach was also vying for the tourist dollar, and they were careful to choose different scenes from the Carolina Beach card seen on page 10, which looks just like this one. Since Kure had one of the first piers on Federal Point, most of the scenes have to do with fishing.

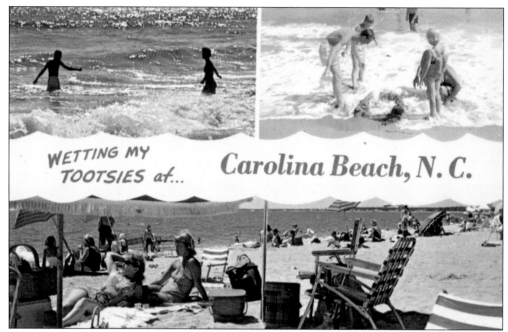

WETTING MY TOOTSIES. Chrome cards began being published in 1939; chrome is short for photochrome and simply means cards made from color photographs. This one is surely from the 1960s–1970s with the metal frame plastic web chair in the bottom scene. Most bathers are still on blankets as they keep watch on the children in the surf.

SPLIT SCENE. There are several different versions of this card with split scenes. They have a brightly colored orange or yellow band running through the middle with wording along with a cartoon picture. This cartoon in the strip shows a couple in an open car racing to the beach with their suitcases sitting in the back seat.

THE GOLDEN STRAND. The writing on this card is stamped on rather than printed. This enabled the same card to be used for several different beach locations. The lady sitting on the blanket has a transistor radio and is wearing a fancy bathing cap; both of these items were in lots of beach bags at that time.

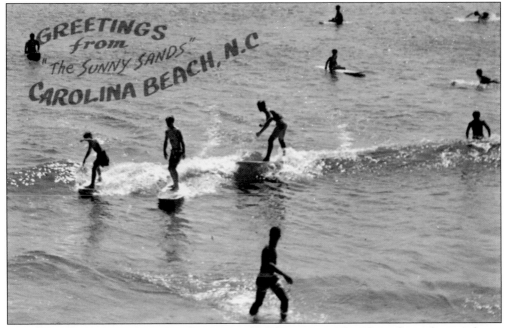

THE SUNNY SANDS. This is another stamped on lettering card with surfers, who are always in abundance at the beach. When the surfing craze began on the West Coast in the 1960s, Carolina Beach was the home of East Coast Surf Boards, handmade by partners Lank Lancaster and Harold Petty from 1964 to 1967. They were pioneer surfboard makers on the East Coast.

BEACH CROWD. On the upper left side of this card of a crowded beach is a jetty, or groin, as they were sometimes called. They were usually rows of creosote posts jutting out into the ocean, which at the time were thought to prevent erosion. This card is probably not Carolina Beach since the jetties there were made of rocks unlike Kure Beach, which did have wooden ones.

BEACHGOERS. This is a fairly modern picture of beachgoers as evidenced by the style of chairs and the absence of blankets. By this time, Carolina Beach, Wilmington Beach, Hanby Beach, Kure Beach, and Fort Fisher were going by the collective name of Pleasure Island. Later Wilmington Beach was annexed by Carolina Beach and Hanby Beach, and the northern part of Fort Fisher became part of Kure Beach, making two municipalities on Federal Point.

Two

EARLY DAYS

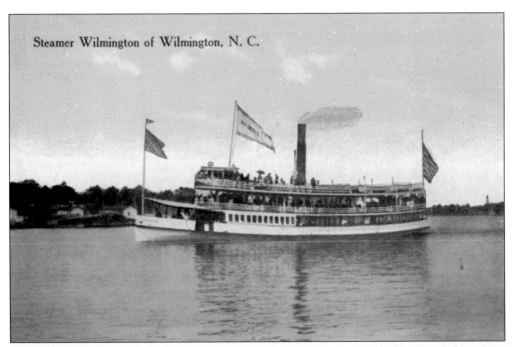

Steamer Wilmington of Wilmington, N. C.

STEAMER *WILMINGTON*. A steamer was the first leg of a journey to Carolina Beach from 1887 to about 1919. The *Wilmington,* piloted by Capt. John W. Harper, had three decks, providing ample room for its 500 passengers to dance to the music of an onboard band. Cool breezes delighted them on the hour-long Cape Fear River trip from the city to the dock at Federal Point. The *Wilmington* made four round trips daily in the season; in 1892, the ticket price was 50¢ for adults and 25¢ for children. Monday trips were reserved for black excursionists.

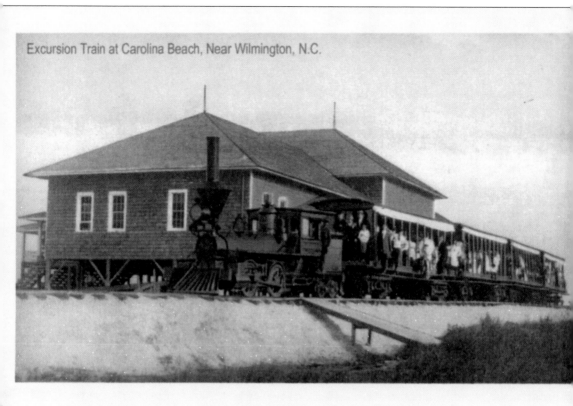

Excursion Train at Carolina Beach, Near Wilmington, N.C.

EXCURSION TRAIN. At the Federal Point dock, located first near Sugar Loaf and later at Doctor's Point, the steamer passengers boarded a train pulled by a wood-burning steam engine. The little train, called the "Shoo Fly" or "Sandfiddler," transported the beachgoers in open cars across the peninsula to the Atlantic Ocean and right up to the back door of the pavilion. The tracks ran along the present-day Harper Avenue; the pavilion was located between Harper and Cape Fear Boulevard facing the ocean. In 1887, the same year the tracks were laid, there was also a Railroad Station Restaurant and Bryan's Oceanic Hotel. A July 24, 1903, edition of the *Wilmington Dispatch* recounts the story of the train being derailed after hitting a cow belonging to Hans A. Kure, who operated a billiard hall, bowling alley, and grocery at the new resort. The train then ran backward to the beach carrying 200 passengers, mostly women and children from the Second Advent Sunday School excursion, who were badly frightened.

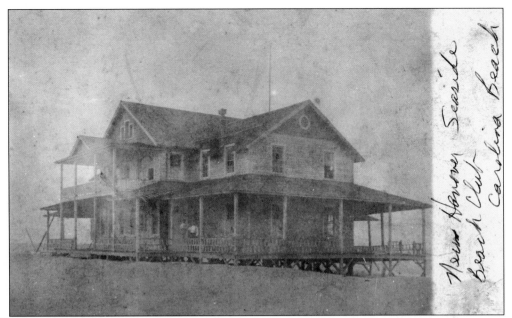

HANOVER SEASIDE CLUB. In 1898, many Shoo Fly passengers were going to the grand new Hanover Seaside Club located oceanfront between present-day Seagull and Sailfish Streets. It was designed by Henry Bonitz and often called the German Club because the majority of the subscribers or members were part of Wilmington's large German population. They enjoyed nine seasons before deciding to build another clubhouse at Wrightsville Beach. (Courtesy of the New Hanover County Public Library.)

LIFELINE. Hanover Seaside Club had a lifeline, also called a safety line, complete with floaters for its surf bathers. Like the one in the card above, it was simply ropes connected to poles anchored deep in the sand. Many early bathers could not swim and felt safer with something to hold on to, especially in the breakers.

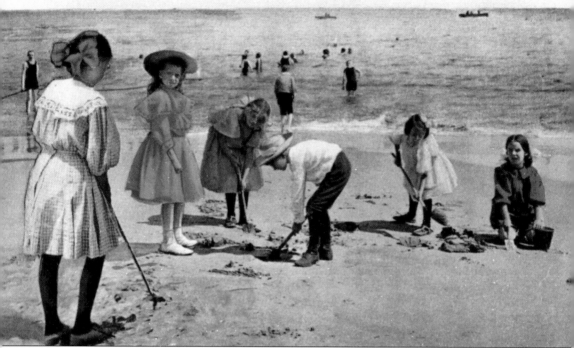

3022 – Fun for the Kiddies on the Beach.

FUN FOR THE KIDDIES. To modern-day beachgoers, it looks very strange to see children dressed with stockings, shoes, dresses, long pants, hats, and hair bows digging in the sand with long-handled shovels, but in the Victorian Age, it made perfect sense. This card is probably not Carolina Beach but does show how some children may have looked coming with their parents on one of the steamers or the Shoo Fly to the beach in the early days. They most likely rented their bathing suits from the bathhouse at the pavilion and folded away the fancy clothes until the trip home. In the background on the right, a bather is holding on to a lifeline that goes out into the water like the one mentioned on the previous page. This is a divided-back card, which means it was printed between 1907 and 1915. (Courtesy of Doris Bame.)

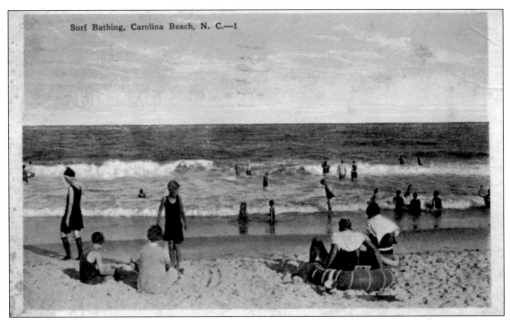

SURF BATHING. Bathers are enjoying the beach in this early, white-border card. The ladies' suits were made of wool jersey and worn with stockings and bathing caps. After being stored for the winter, the suits smelled of moth balls. One lady is sitting on the sand in a dress and hat, no blankets yet. The card was postmarked 1926, and the writer has "been in twice."

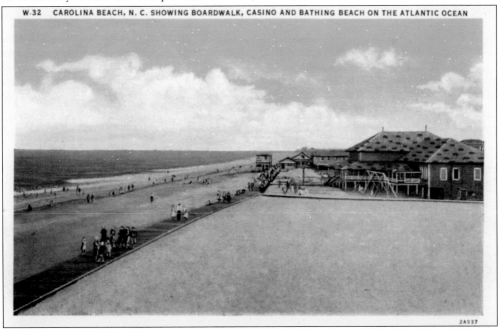

W-32 CAROLINA BEACH, N. C. SHOWING BOARDWALK, CASINO AND BATHING BEACH ON THE ATLANTIC OCEAN

BOARDWALK, CASINO, AND BATHING BEACH. This card shows the pavilion, often called the "Casino," and the boardwalk looking south. There are swings and a merry-go-round where children could play. On July 4, 1922, children's activities included the 100-yard dash, broad jump, potato race, swimming race, and climbing a greased pole. A child's suit rental cost 25¢, but the ice water was free.

23

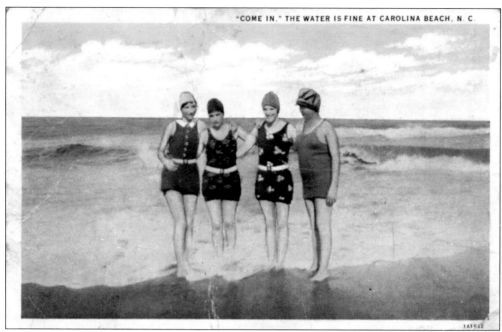

COME IN, THE WATER IS FINE. A white-border card from 1915 to 1930 shows the suits still made of wool jersey but more stylish, with designs and details not seen in the ones on the previous page. Note the collar, belts, and caps but no stockings. The caption on the back talks about the wild waves luring men away from their homes to Carolina Beach and its beautiful women, very provocative talk for the time. On the extreme left is the name of John W. Plummer, who had these cards printed to sell in his store on the Boardwalk south of the pavilion and across from the Bame Hotel on Cape Fear Boulevard. He became the first mayor of Carolina Beach when the town was incorporated in 1925.

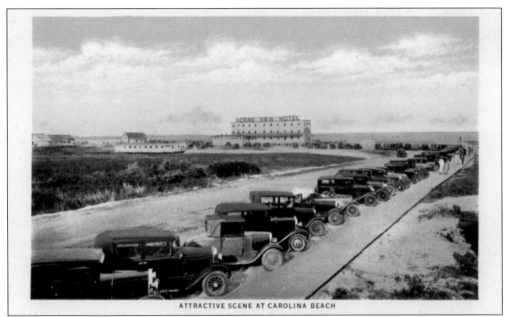

ATTRACTIVE SCENE AT CAROLINA BEACH

ATTRACTIVE SCENE AT CAROLINA BEACH. The Ocean View Hotel was built by lumberman M. C. McIver on four oceanfront lots. It was begun in April and opened on June 15, 1929. The Ocean View had 50 rooms, half of which had a private bath and all with running water. The street with all the cars is Harper Avenue; the pavilion was a half block south.

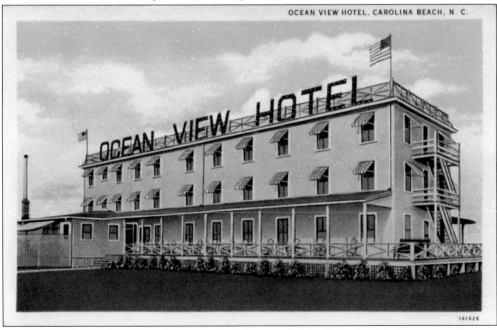

OCEAN VIEW HOTEL, CAROLINA BEACH, N. C.

OCEAN VIEW HOTEL. The small building attached to the back porch of the Ocean View was the dining hall. The McIvers walked there for evening meals from their cottage just north of the hotel. In 1931, M. C. McIver was elected mayor of Carolina Beach by a landslide—86 to 41. On December 26, 1932, the hotel was destroyed by fire, the cause of which was believed to be arson; the Depression dashed plans to rebuild.

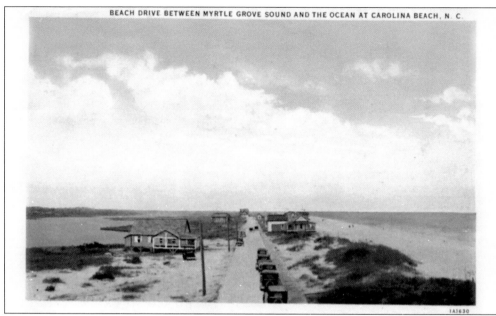

BEACH DRIVE. Postmarked in 1936, this card shows the northern end of Carolina Beach with a new hard surface drive. Electricity was first generated at the beach in the late 1880s. Telephone service began in 1898, and by 1903, there were three pay stations. Direct service, via a dial system, began in June 1938. The 1941 phone book had one page for Carolina Beach's 75 listings and included instructions for using a dial phone.

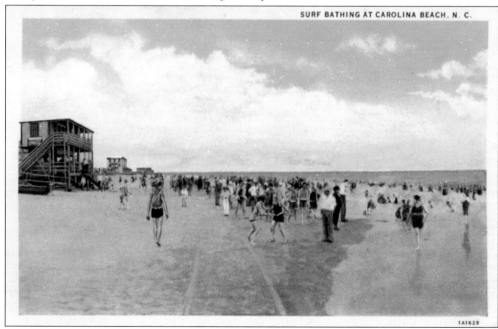

TRACKS ON THE BEACH. Note the tire tracks in the foreground; the back reads, "Carolina Beach is such a fine, hard beach that on low tide automobiles are driven for miles right out on the water's edge." A 1928 edition of the *Wilmington Star* advertised an automobile race on the strand, stating, "Six well known drivers speed along at 90 and 100 miles per hour, Thrills Assured, Admission $1."

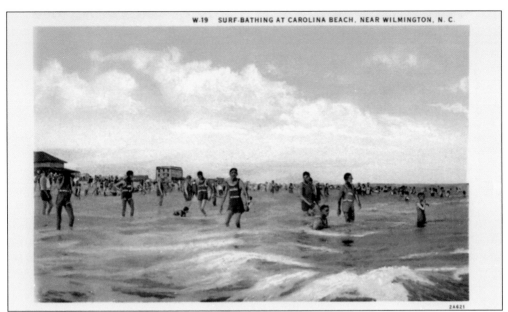

SURF WADING. On the left is the pavilion designed by Henry Bonitz and built in 1911 to replace the one that burned. It was called by many names: Casino, Carolina Moon, Carolina Club Casino, and Carolina Club. South of the pavilion, the first fishing pier on Federal Point was built in 1915-1916. It went out 600 feet; the end was tied to the wreck of the sunken blockade runner *Beauregard*.

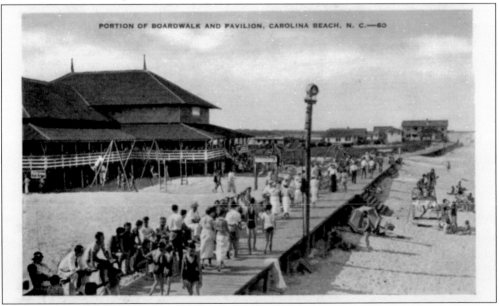

PORTION OF BOARDWALK AND PAVILION, CAROLINA BEACH, N. C.—60

PORTION OF THE BOARDWALK AND PAVILION. This view of the pavilion looking north must be after 1932 because the Ocean View has been replaced by Watson's Rooms and Apartments and other cottages. The wooden boardwalk has benches and enough room underneath for shade seekers. In July 1930, the pavilion presented welterweight, middleweight, and lightweight boxing matches illustrating its versatility. Some of the boxers were Wilmington boys Ken Burris, Carter Casteen, and Hugh Perry.

27

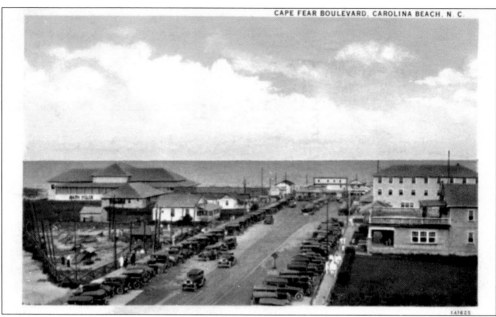

CAPE FEAR BOULEVARD. The pavilion is on the left, facing the ocean; in front is an early miniature golf course. Across the street is the wooden Bame Hotel, built in 1930. West of that is the Greystone Hotel, built of blocks made of beach sand; it opened in 1916 and later featured a rooftop Japanese garden. The building is still standing and houses the Trolley Stop hot dog stand.

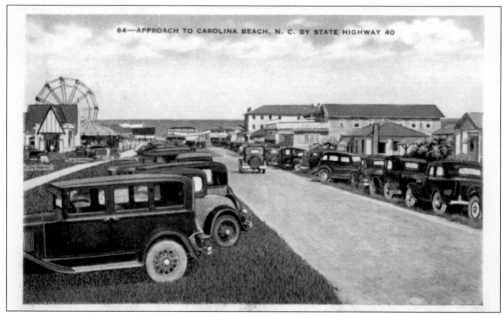

64—APPROACH TO CAROLINA BEACH, N. C. BY STATE HIGHWAY 40

APPROACH TO CAROLINA BEACH. A few years later, the same street scene shows additions of a Ferris wheel, a merry-go-round, and a gas station facing Lake Park Boulevard. All those cars would need the station; a 1933 *Wilmington Star* article stated that 7,051 automobiles passed over the bridge on July Fourth, the people count was estimated at 10,000, and parking was a big problem.

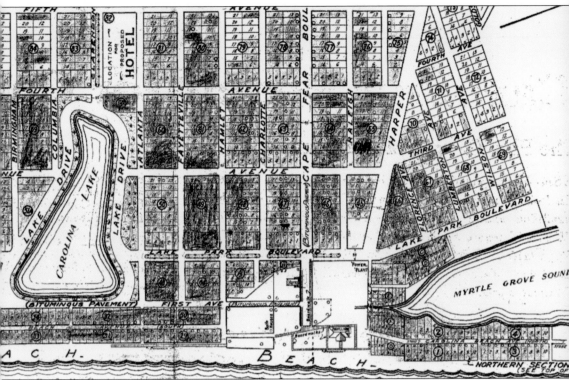

MAP. The Carolina Lake is very prominent in this portion of a 1925 map of Carolina Beach. It shows a Lake Drive all around the lake and Lake Park Boulevard making a left turn to go around the lake via First Avenue. West of the lake is a block laid out for a proposed hotel. The Carolina Beach Hotel, which had a dining room, ballroom, and 100 guest rooms, opened in June 1926. It was there only two seasons and burned in September 1927, with its two owners being rescued from the roof during the fire. Having only bought the property in late July, they were conducting an inventory of the hotel with plans to keep it open year-round. By November, after an extensive investigation, those same owners were arrested and indicted on charges of arson. That block is now the site of Carolina Beach School. Looking down to the boardwalk area is the pavilion facing the ocean. A block west of that on Cape Fear Boulevard is the Greystone Hotel, built in 1916. (Courtesy of Bill Auld.)

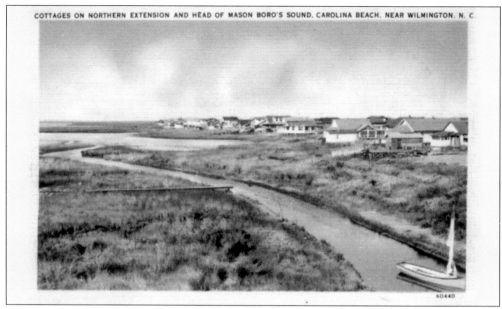

60440

COTTAGES ON THE NORTHERN EXTENSION. Since postcards were not printed locally in the early days, mistakes often occurred with regional spellings as in this case with Mason Boro instead of Masonboro. The meandering slough, shown, was dredged and widened in 1939, creating the boat basin and a navigable canal connecting to the newly dug Intracoastal Waterway. The dredge spoil created building lots and a new street later named Canal Drive.

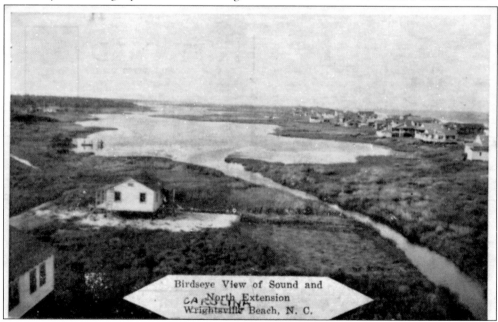

Birdseye View of Sound and
CAROLINA North Extension
Wrightsville Beach, N. C.

VIEW OF SOUND AND NORTH EXTENSION. This photograph card is not the northern end of Wrightsville Beach but is Carolina Beach, just as the correction states. It was probably used to create the card at the top of the page. The photograph also shows two houses across the canal on the St. Joseph's side, named by Joseph Winner, who bought 100 acres there in 1880 to start a town.

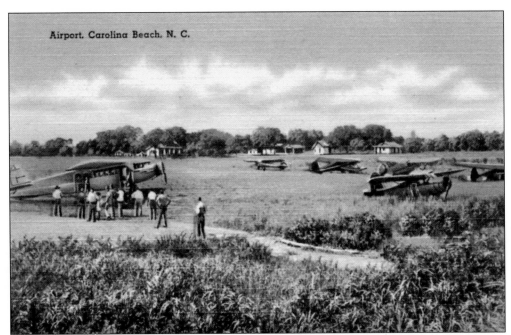

Airport. Carolina Beach, N. C.

AIRPORT. In 1941, this flying field was opened by brothers Jimmy and Warren Pennington on Carolina Beach Road. This field was located a quarter mile before the Inland Waterway Bridge behind present-day Mount Pilgrim Baptist Church. Three planes were used for pilot lessons and for flying sightseers over the beach. In 1946, they moved back to the county airport, which had been taken over by the government during World War II.

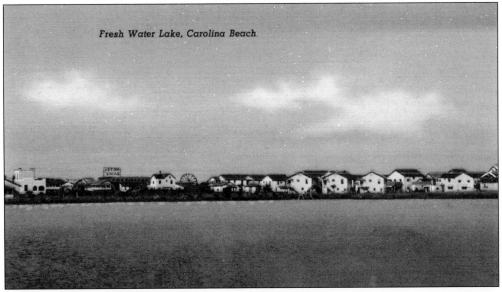

Fresh Water Lake, Carolina Beach.

FRESH WATER LAKE. Historically this lake was known as the Carolina Lake and Fresh Water Lake. As mentioned on page 26, a new hotel opened next to this lake in 1926. The three-story Carolina Beach Hotel boasted of being next to the only freshwater lake within a stone's throw of the ocean. Open only two seasons, it burned in the fall of 1927. Carolina Beach School sits on the site today.

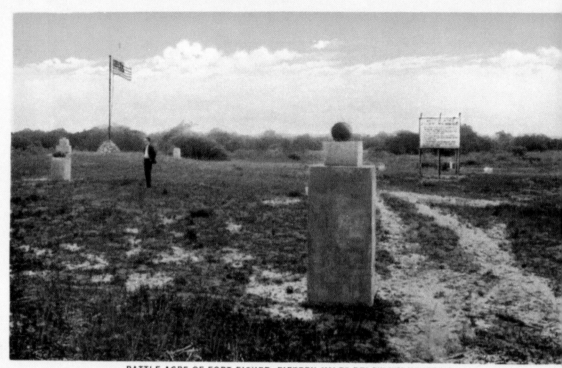

BATTLE ACRE OF FORT FISHER, FIFTEEN MILES BELOW WILMINGTON

BATTLE ACRE, FORT FISHER. Fort Fisher played an important role in the Civil War by helping to keep the port of Wilmington open to blockade runners bringing vital supplies to Confederate armies. Col. William Lamb, Fort Fisher's last commander, was largely responsible for designing and supervising the construction of the biggest and by 1864 the most important fortification in the South. His soldiers, along with more than 500 enslaved and free African Americans built the fort's huge sand batteries. During his stay, Lamb made the Federal Point Lighthouse caretaker's cottage his headquarters. The cottage and a nearby flagpole were destroyed by a Union naval bombardment on Christmas 1864. The flag in this card marks the location of that flag. Colonel Lamb then instructed that another flag be raised on the Mound Battery. When it too was shot away, Pvt. Christopher C. Bland shinnied up the flagpole and reattached it. Fort Fisher fell on January 15, 1865, thus closing the last supply route of Gen. Robert E. Lee's Army of Northern Virginia and sealing the fate of the Confederacy.

Three

STREET SCENES

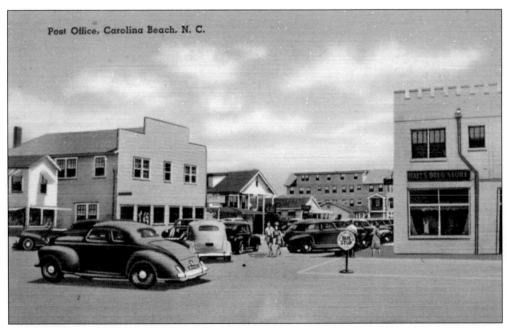

Post Office, Carolina Beach, N. C.

POST OFFICE. A glimpse of downtown Carolina Beach in the early 1940s shows the corner of Lake Park Boulevard and Harper Avenue. The building on the right is the Carolina Beach Drug Store showing its decorative battlement parapet. The post office at that time was located across the street. The side of the four-story Risley's Cottages are on the east end of Harper.

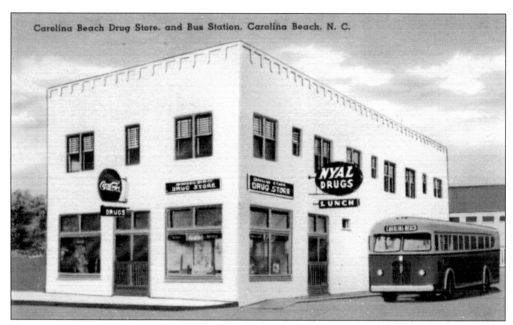

Carolina Beach Drug Store. and Bus Station. Carolina Beach. N. C.

CAROLINA BEACH DRUG STORE AND BUS STATION. During World War II, soldiers were lined up around the block to catch a bus back to Camp Davis, Fort Bragg, or Camp Lejeune at the corner drugstore, which doubled as a bus station until the late 1940s. Many pharmacists operated there over the years, including J. C. "Mike" Hall, Luther Bunch, Wilbur Adams, Neil Musselwhite, and Neil Pharr.

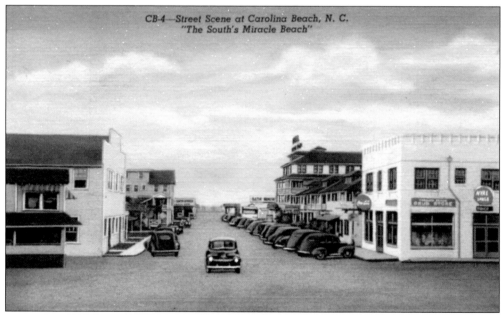

CB-4—Street Scene at Carolina Beach, N. C.
"The South's Miracle Beach"

HARPER AVENUE. Looking toward the ocean is another view of the Harper Avenue and Lake Park Boulevard corner. Behind the drugstore are the three buildings of the Fountain Apartments and beyond them is the Hotel Royal Palm, all built by W. G. Fountain in the mid-1930s. He was later a mayor of Carolina Beach. Across from the hotel are Risley's Cottages, now the site of a parking lot.

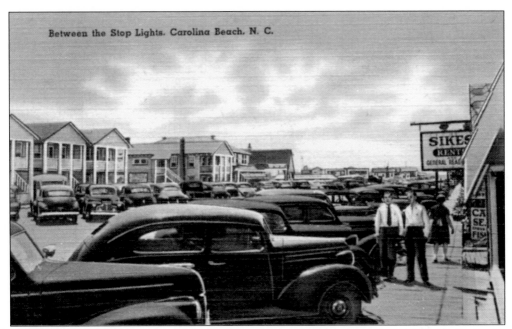

BETWEEN THE STOP LIGHTS. Lake Park Boulevard was the only street with stoplights in the early days. The fifth and sixth buildings on the left are the Wanda Inn, with its awning over the front porch, and the Pure Oil Station, with its large, pointed roof on the corner of Cape Fear Boulevard. A 1932 *Wilmington News* article counts the weekend attendance at more than 4,000 people with parking taxed to the limit.

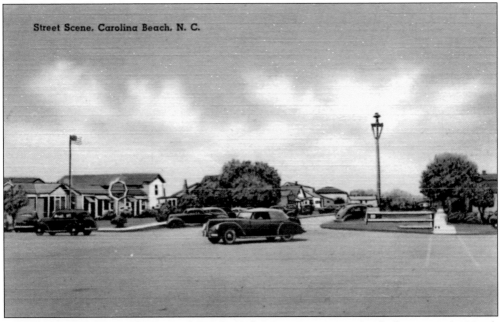

STREET SCENE. West of Lake Park Boulevard the streets were named after towns in North Carolina, such as Lumberton, Goldsboro, Charlotte, and Raleigh. Developers of the beach, the New Hanover Transit Company, laid out hundreds of lots in this section of town; in 1916, a lot could be had for as little as $100.

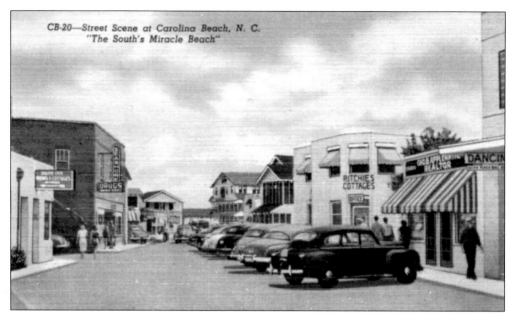

CB-20—Street Scene at Carolina Beach, N. C.
"The South's Miracle Beach"

BUSY STREET. On the far right in this postcard is the edge of the Ocean Plaza Ballroom. Left of it as one looks up Carolina Beach Avenue North is George Applewhite, realtor. Both buildings were torn down in 2006. Beyond that is Ritches Cottages; next door is Farmer's Cottages. Across the street is the Dunn Inn and Seashore Drugs building, which was later a skating rink, a teen club, and a business named King's Beachwear.

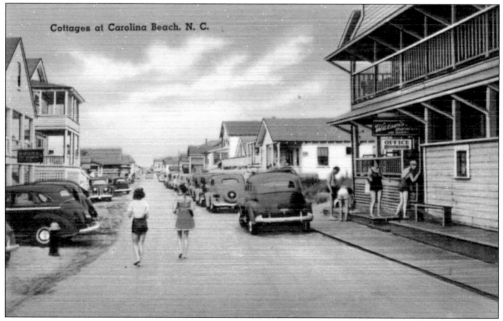

Cottages at Carolina Beach, N. C.

COTTAGES AT CAROLINA BEACH. This linen card is also looking up Carolina Beach Avenue North. On the right, Watson's Rooms and Apartments, a very popular place to stay at the beach because of it proximity to the boardwalk can be seen. Watson's was just north of Farmer's Cottages in the card above. Both were located on the site of the 1930s Ocean View Hotel, where the Cabana Suites are today.

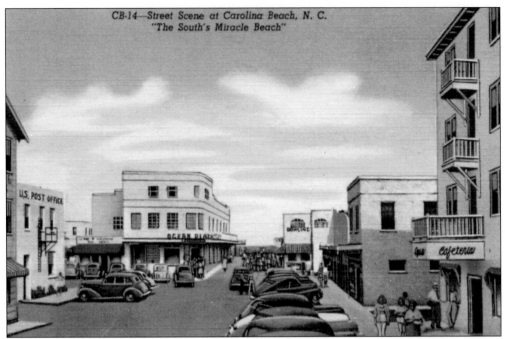

END OF HARPER AVENUE. The cafeteria and balconies of the Royal Palm Hotel are on the right of this linen card with the post office across the street. The Ocean Plaza, built in the Art Moderne style by E. A. Reynolds in 1946, sits ready for bathhouse or restaurant patrons on the first floor, dancers on the second floor, with the Reynolds' living quarters on the third.

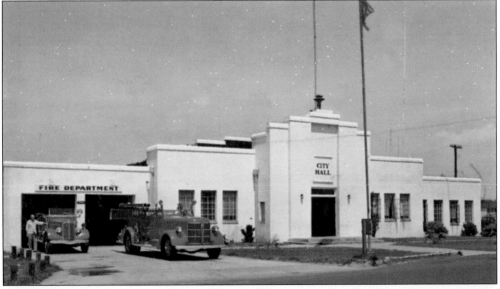

MUNICIPAL BUILDING: CITY HALL AND FIRE DEPARTMENT. Opened in 1942 and partially built with WPA funds, this Art Moderne building was on Canal Drive with its right side facing the yacht basin. It had an auditorium holding 800, offices for police and firemen, a jail for whites, a jail for blacks, a kitchen, and a recreation room, and in 1950, it housed the library. Community activities from stage shows and bridge parties to church league basketball were held in this building.

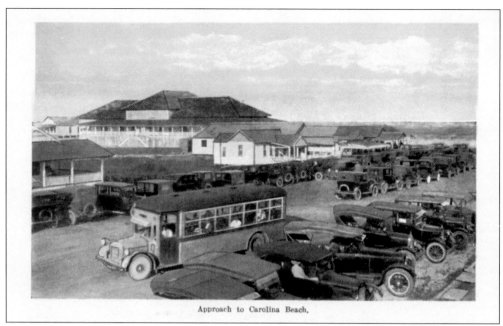

Approach to Carolina Beach.

APPROACH TO CAROLINA BEACH. This is Cape Fear Boulevard looking north toward the back of the pavilion. One of the buildings facing the street was Plummer's Store, where postcards and groceries could be bought and mail could be picked up. The Plummers' residence was next door. The bus could have been a 16-passenger Studebaker, which started making 25¢ trips to the beach in 1916 over a newly completed, macadamized road.

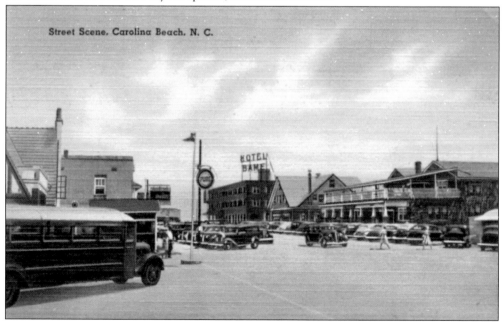

Street Scene, Carolina Beach, N. C.

STREET SCENE. A later model bus pulls onto Cape Fear Boulevard showing the other side of the street from the card above. The Hotel Bame sits on the boardwalk with a gas station and grocery store between it and the Greystone Hotel. A. W. Pate, president of the New Hanover Transit Company, which had hundreds of lots for sale at the beach, built the Greystone in 1916.

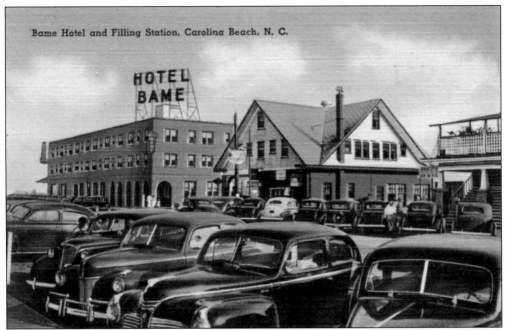

BAME HOTEL AND FILLING STATION. The edge of the Greystone Hotel's Japanese roof garden is just visible on the right of this linen card. The roof garden was a very popular spot to catch cool ocean breezes on warm summer nights while dancing to big band sounds. The brick Bame Hotel replaced the wooden one, built in 1930 by James Rowan Bame, which burned in the 1940 boardwalk fire.

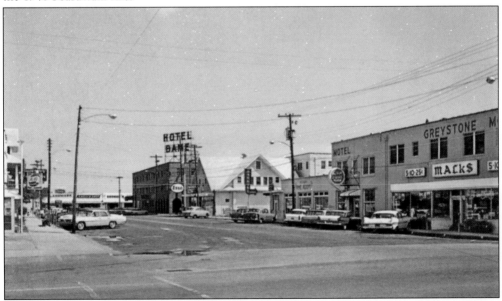

CAPE FEAR BOULEVARD. Cars from the 1960s are parked along Cape Fear Boulevard in this chrome card. Second generation Bames are operating the hotel and filling station, but the Greystone is now a motel atop Mrs. High's Dining Room and a Mack's Five and Ten, which used to be the A&P Grocery Store. People drove from miles around to eat seafood platters at Mrs. High's Pine Room.

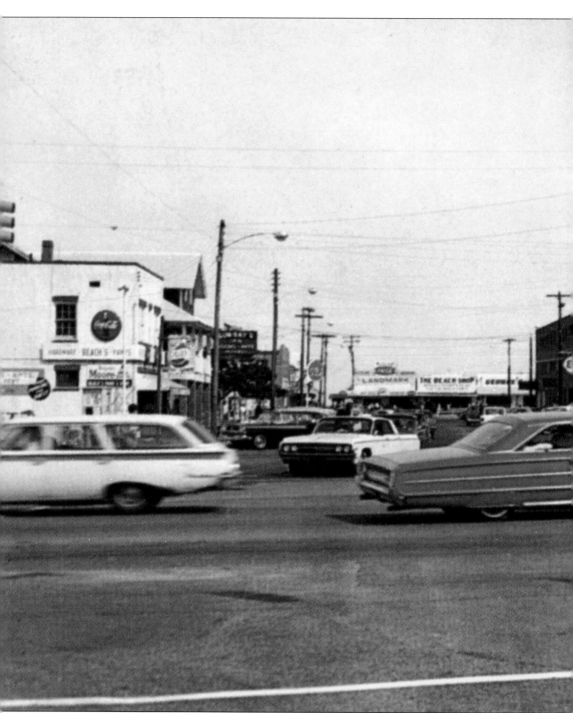

DOWNTOWN VIEW. From Lake Park Boulevard, a 1964 two-door, hardtop Ford with fender skirts turns onto Cape Fear Boulevard and will be looking for a parking space from the looks of the crowded streets. The Greystone has certainly changed from its 1916 appearance. Long gone is the roof garden over Lille Mae High's Pine Room with its striped awning. Mrs. High's started out as a diner in a converted trolley car next to the original hotel. A. W. Pate, the

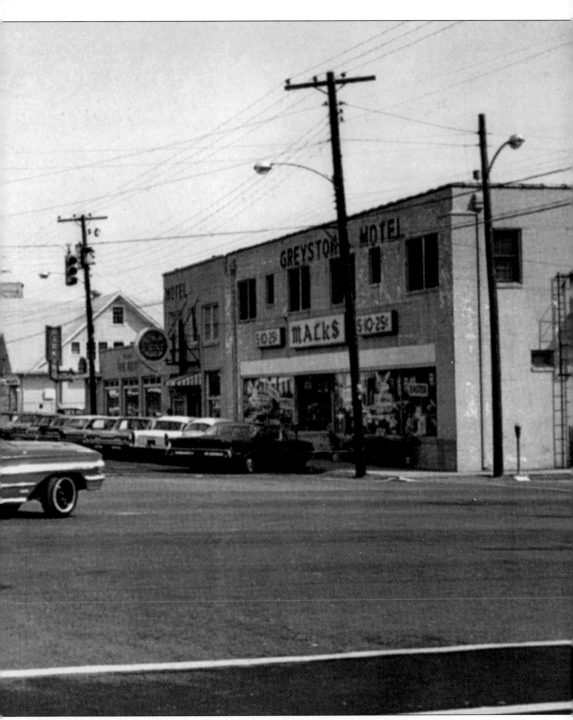

owner, had plans to build a Wilmington–to–Carolina Beach trolley originating in the Sunset Park area of the city, but those plans didn't materialize. So, in 1939, he settled for a trolley diner. Beyond the Bame Hotel are some of the boardwalk businesses, including the Landmark, the Beach Shop, and George's Bingo.

SHAVER ESSO SERVICENTER. Shaver's was located on Lake Park Boulevard not far from the bridge on the left coming into town. The gas prices are enviable with today's high-dollar fuel, just 29.9¢ for regular and 32.9¢ for high test, as it was called in those days. At Shaver's, you could fill up and "put a tiger in your tank."

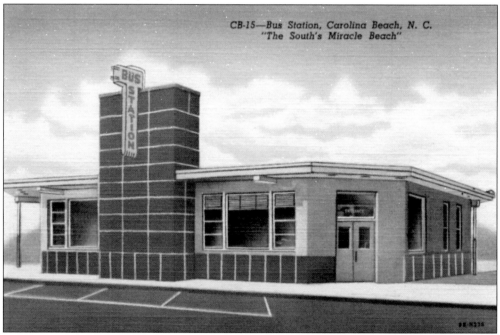

BUS STATION. Queen City Coach Company built this modern bus station in 1948 on Lake Park Boulevard and Raleigh Avenue to replace the bus stop in the Carolina Beach Drug Store across the street. It later became the Battery Restaurant; then in 1983, it was redesigned to become a branch of Carolina Savings and Loan. It is now the Carolina Beach branch of BB&T.

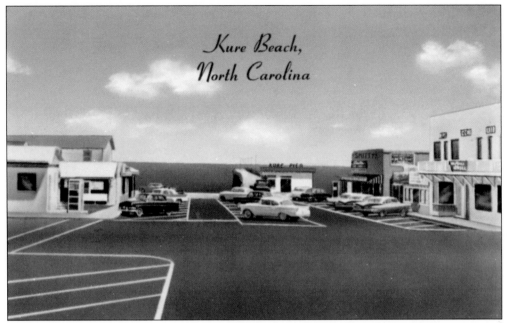

Kure Beach, North Carolina

KURE BEACH. Where K Avenue meets the ocean is the famous Kure Pier, the heart of this small town. To the right of the pier, barely visible, is the Pier House Restaurant, which used to be the actual pier house. Next to that are Smitty's, the tiny post office, Watson's Tackle and Grocery, and the Plaza Grill building with ocean-view rooms and apartments on top.

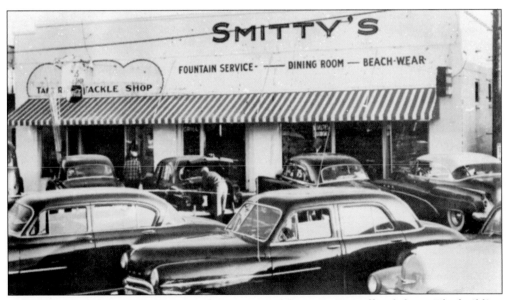

SMITTY'S. A closer view of Smitty's shows some of the amenities offered there. The building still stands on K Avenue, which was the path of a railroad from the Cape Fear River to the ocean built by the town's founder, Hans A. Kure Sr., and his four sons around 1913. They brought building materials for the town as well as beachgoers who came to spend a day.

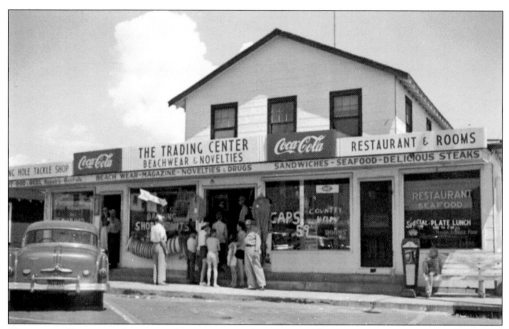

TRADING CENTER. Across K Avenue was a forerunner of a strip shopping center called the Trading Center. It included the Fishing Hole Tackle Shop, a beachwear and novelty shop, and a restaurant. According to the back of this card, the restaurant served "Mrs. Davis' home-cooked meals along with those famous 'Mrs. Davis' homemade hush puppies." Above the businesses were rooms to rent.

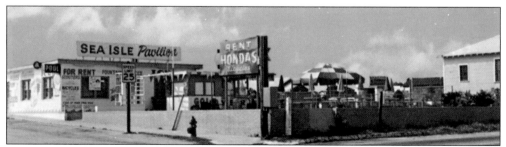

SEA ISLE PAVILION. On the corner of K Avenue and Highway 421 was the Sea Isle Pavilion, owned and operated by Tommy Lancaster Sr. from Goldsboro. They had Honda scooters and bicycles to rent for vacationers who wanted to ride around and see the sights. The Sea Isle had an ice cream parlor, a miniature golf course, a jukebox with a dance floor, and at one time trampolines.

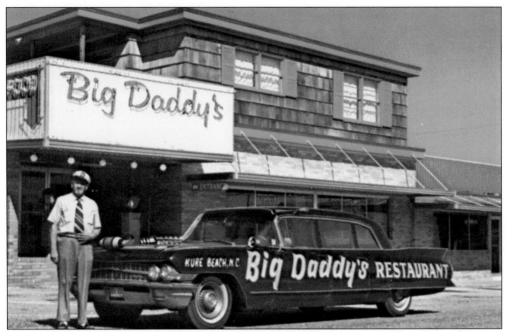

BIG DADDY'S. Later Tommy "Big Daddy" Lancaster built this restaurant on the same corner with living quarters upstairs. His traveling billboard Cadillac with a longhorn hood ornament that turned heads wherever it went hopefully enticed diners to try his fare. He later opened another Big Daddy's at Lake Norman near Charlotte. (Courtesy of Wayne Bowman.)

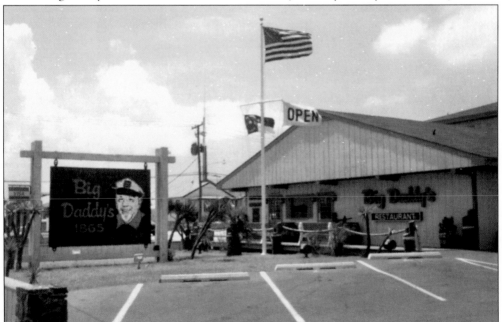

REMODELED BIG DADDY'S. An addition on the front was added later to enlarge the restaurant and make a lobby for the multitude of diners waiting for a table. A caricature of Big Daddy with his signature captain's hat is on the sign out front. Operated by different owners now, they are wisely keeping the name of this landmark at Kure Beach.

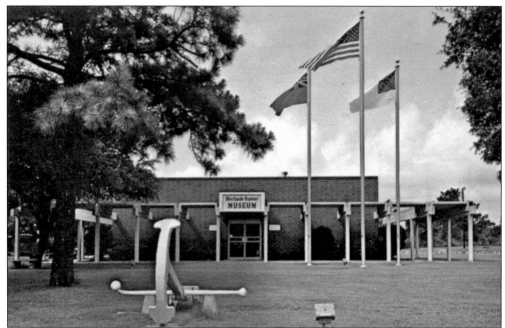

BLOCKADE RUNNER MUSEUM. In July 1967, and under the direction of John Hanby Foard, the Blockade Runner Museum opened its doors on Highway 421, also known as Lake Park Boulevard. Foard created and built the museum from his love and study of the Civil War. The museum's focal point was a diorama of Fort Fisher.

SLAVE MARKET, BLOCKADE RUNNER MUSEUM. To the left rear of the museum sat a replica of an old slave market. It was used as a picnic shelter for school groups and others who visited the museum. Later it was enclosed and today serves as the home of the Federal Point Historical Preservation Society.

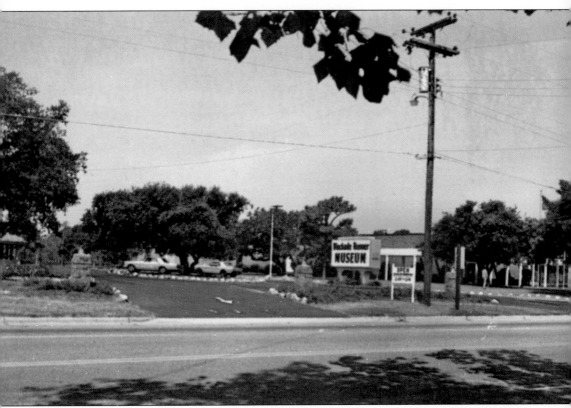

MUSEUM COMPLEX. Under the spreading oaks are the slave market (left) and museum (right). The museum closed in September 1982 after a failed effort for the State of North Carolina to take it over. For the next few years, it was used as a real estate office. During those years, many supported buying it to replace the old Municipal Building on Canal Drive, which always flooded during storms and hurricanes. In April 1989, after months of debate, the Carolina Beach Town Council bought the building and grounds for $398,000; the decision was spurred on because council knew that Interstate 40 would soon open and prices along the Highway 421 corridor would soar. At first, just the administrative offices moved into newer quarters, leaving the police, fire, harbor master, and recreation departments to spread out in the 1942 building. After back-to-back hurricanes Bertha and Fran in 1996, the police and recreation departments began relocating to the converted museum, which today is the handsome town hall complex. The fire department relocated to a new building on Dow Road.

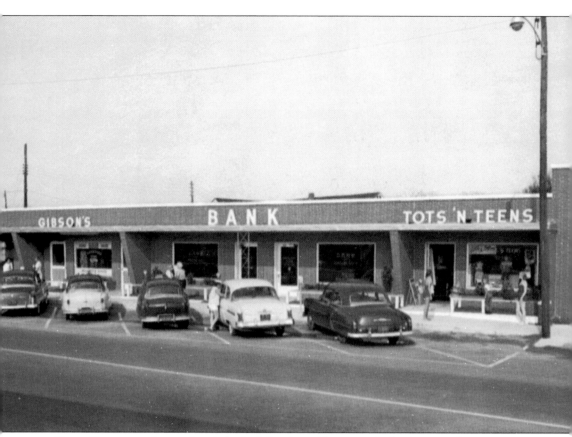

BANK BUILDING. Located on Lake Park Boulevard between Carl Winner and Harper Avenues, this 1956 building was the equivalent of today's strip mall. At the far left, out of camera range, was the post office. The post office has had many locations over the years, including Plummer's Store on Cape Fear Boulevard, the corner of Harper Avenue and Carolina Beach Avenue North, and the corner of Harper Avenue and Fifth Street. The other shops on this card are, from left to right, Gibson's Drug Store (notice the wooden screen door), the Bank of Carolina Beach, and the Tots 'N Teens shop. On the far right is the garage of a service station located on the corner of Harper Avenue and Lake Park Boulevard.

Four

ACCOMMODATIONS

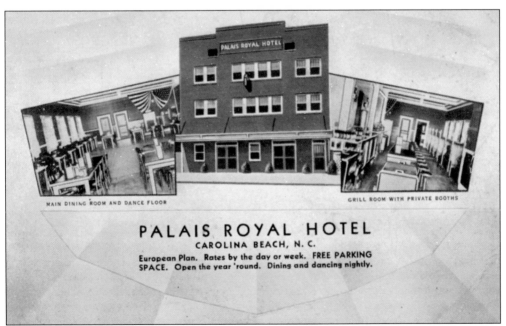

PALAIS ROYAL HOTEL
CAROLINA BEACH, N. C.
European Plan. Rates by the day or week. FREE PARKING
SPACE. Open the year 'round. Dining and dancing nightly.

PALAIS ROYAL HOTEL. Built in 1937, the Palais Royal was on the boardwalk facing the ocean. The first floor had a main dining room with dance floor, often used for civic meetings, and a grillroom cafe with booths. Hotel rooms with ocean views occupied the top two floors. The Palais Royal was burned in the boardwalk fire of 1940; it was rebuilt in 1941 as a two-story building and lasted until Hurricane Hazel in 1954. (Courtesy of Wayne Bowman.)

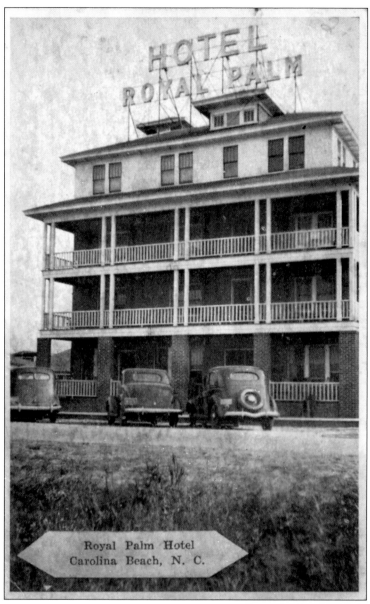

Royal Palm Hotel
Carolina Beach, N. C.

ROYAL PALM HOTEL. W. G. Fountain built the four-story, 58-room Royal Palm Hotel in 1936 next door to Fountain's Rooms and Apartments, which he built the year before. The hotel was located on the corner of First Avenue, later named Woody Hewett and Harper Avenue. The tale is told that Fountain measured the perimeter and height of the hotel, subtracting for doors and windows, and ordered the brick. When the hotel was finished, there was only one wheelbarrow of brick left. An astute businessman, he also owned Fountain Oil Company in Castle Hayne. The Fountains' only daughter, Lila, was crowned Miss Carolina Beach in 1939. The couple also had seven sons; Clayton, Alton, Millard, Elmo, Woodrow, Gus, and Archie worked in the businesses growing up. Elmo managed the hotel from the late 1940s to early 1960s, while his wife, Plina, ran the apartments. Their daughter, Sylvia, is the girl on the right on the back cover of this book. During their management, famous Wilmingtonian Meadowlark Lemon worked one summer at the hotel as a bellhop.

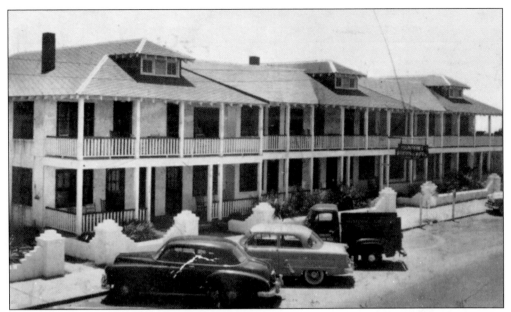

FOUNTAIN'S ROOMS AND APARTMENTS. In 1935, W. G. Fountain built three, two-story stucco buildings with 20 rooms each on Harper Avenue. J. T. Ritter from Castle Hayne supplied millwork; stucco, lumber, doors, and windows came from Becker's Building Supply. J. C. Penney furnished sheets, towels, shades, and curtains, while the glassware and dishes came from Kress. In 1959, the rooms and apartments were sold and moved to make way for a parking lot.

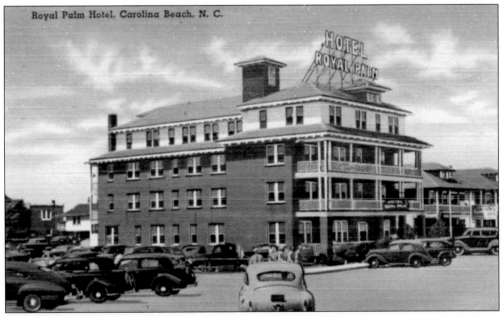

Royal Palm Hotel, Carolina Beach, N. C.

ROYAL PALM HOTEL, SIDE VIEW. The rooms and apartments can be seen on the right of the hotel in this linen card. In January 1945, James Hayes, who was the hotel manager, broke his back in a bad fall. Not realizing that the elevator car was on the third floor, he unlocked the lobby elevator entrance to escort two marines to their room and stepped in, falling to the basement.

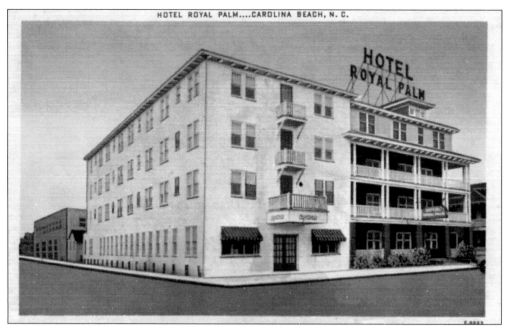

HOTEL ROYAL PALM AND WING. In 1946, an east wing containing 50 more rooms was added to the hotel. It was built over a full-service cafeteria that held 100 people just a block from the boardwalk. That same year, a three-year-old boy tumbled from a third-story window ledge at the hotel. Miraculously he recovered with no broken bones after being rushed to Babies Hospital at Wrightsville Beach.

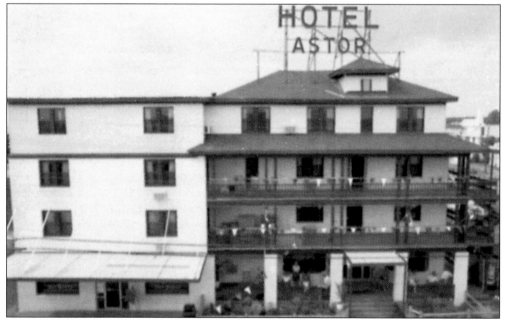

HOTEL ASTOR. By the early 1980s, the Royal Palm had fallen into disrepair. It was purchased by Vince and Dee Bolden, who renamed it the Hotel Astor and reopened it in June 1983 after an extensive renovation. They covered the brick with stucco and remodeled the 107 rooms into 53 more spacious ones, each with a bath. It burned to the ground in 2005, a victim of arson.

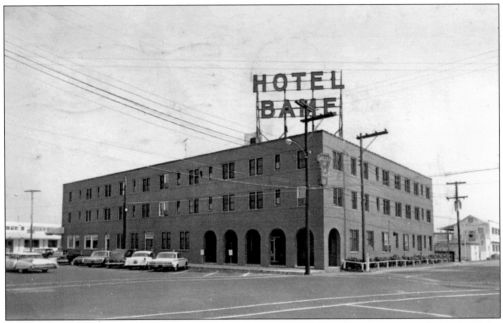

HOTEL BAME. The wooden Hotel Bame opened in 1930 with 36 rooms and was built by James Rowan Bame of Barbor, North Carolina. He added 32 more rooms in 1939, but just a year later, the hotel became one of the casualties of the tragic boardwalk fire. This chrome card shows the new building, which opened in 1941 with an elevator serving 80 rooms, 65 of those with a private bath.

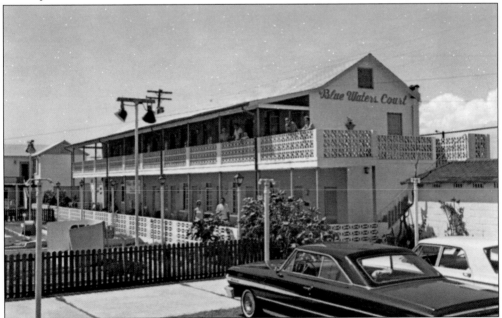

BLUE WATERS COURT. Blue Waters can be seen on the right edge of the card above. It faced the boardwalk with its back to the street, behind the Hotel Bame. In front of the motor court was a miniature golf course, one of the many Seashore Amusements at that end of the boardwalk. Guests of the Blue Waters were truly in the center of the beach's amenities.

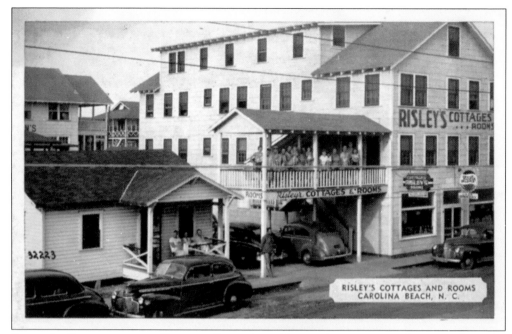

RISLEY'S COTTAGES AND ROOMS
CAROLINA BEACH, N. C.

RISLEY'S COTTAGES AND ROOMS. Situated on Harper Avenue across the street from the Royal Palm, Risley's was a bustling center of activity. Margaret and Eugene F. Risley boasted that each room had hot and cold water, and each bed had an innerspring mattress. On the street level was Lyle's Grocery, very conveniently located for the guests above.

WANDA INN, CAROLINA BEACH, N. C.

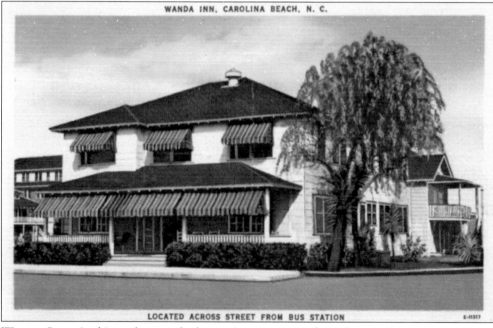

LOCATED ACROSS STREET FROM BUS STATION

WANDA INN. As this card states, the bus station was across from the Wanda Inn on Lake Park Boulevard near the corner of Cape Fear Boulevard. The awnings shaded the rooms and porch from the hot afternoon sun. Wallace and Currie Hawley Aman owned and operated the inn when this linen card was printed, and the phone number was 3321. The Wanda is still in operation.

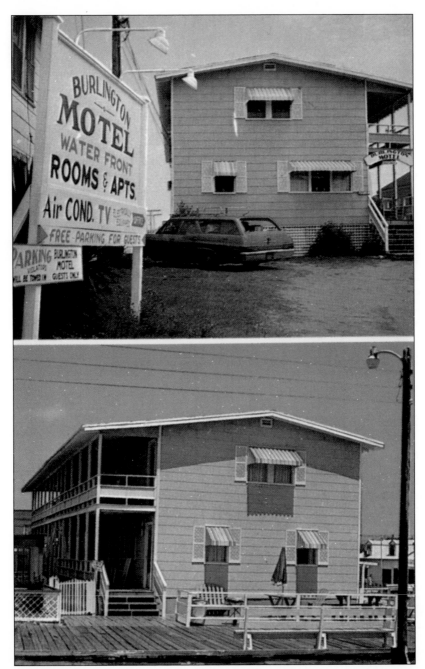

Burlington Motel. Just a few yards north of the Ocean Plaza, the Burlington was near the boardwalk and all its activities. It was oceanfront with rooms and apartments and free parking on its grassy lot out front. This card shows the front facing Carolina Beach Avenue North at the top and the end facing the ocean at the bottom. The Burlington's guests may have needed ear plugs on nights when the Ocean Plaza was hopping, music trailing from its open windows. Fats Domino played there in July 1972 according to an article in the *Wilmington Star*. The Burlington's porch was enclosed and another one added on in later years. Though it is now the Seaside Inn, the curved sign over the entrance is still there.

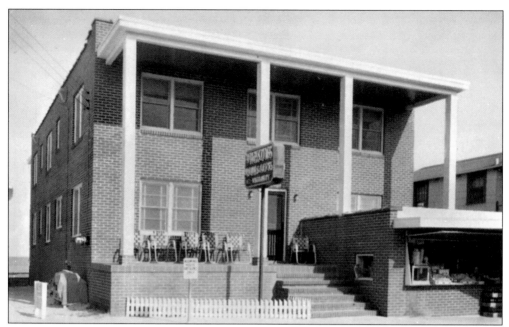

PARSON'S ROOMS AND APARTMENTS. Brick buildings were thought to withstand fire and hurricanes better than wooden ones and were often seen along Carolina Beach Avenue North. Parson's was in the 200 block on the ocean side. The front porch faced the street and half was converted into a concession stand for its guests and the many people who passed back and forth on their way to the boardwalk.

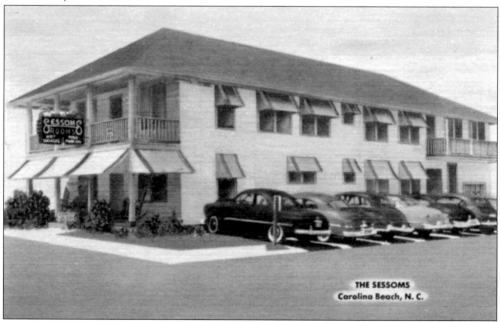

SESSOMS. Also in the 200 block of Carolina Beach Avenue North and across the street from Parson's, the Sessoms had plenty of off-street parking along the side. It was owned and operated by Novella and Edgar Sessoms. In later years, it was part of the many buildings known as the Surfside Motel. It suffered fire damage in the fall of 2006 and was bulldozed in early 2007.

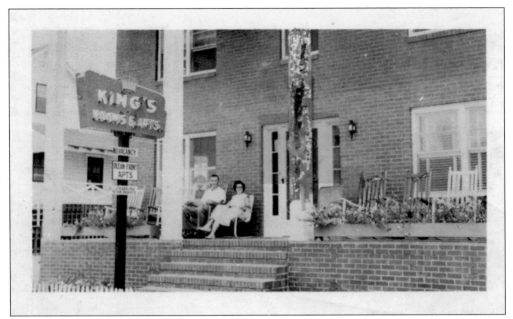

KINGS WATERFRONT ROOMS AND APARTMENTS. A very relaxed couple sits on the spacious porch, enjoying their beach vacation at Kings in the 300 block of Carolina Beach Avenue North. At that time, the establishment was owned by Lee and Leonard B. King and looked like a brick, two-story building, but the brick was just a facade. The sides and back were asbestos siding.

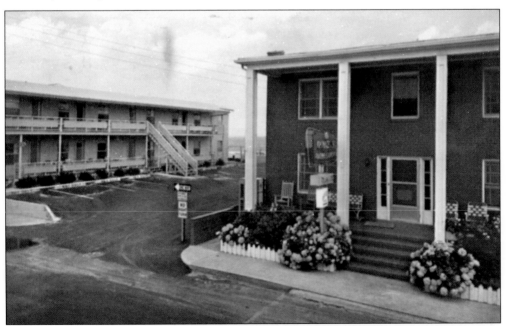

KINGS HOTEL. Postmarked in 1975, this chrome card shows that the Kings have replaced the wooden cottage next door with a two-story modern motel and a parking lot right on the ocean. They also replaced some of the rockers on the porch with webbed aluminum frame folding chairs, which didn't need painting every year. In later years, they sold the hotel, and it eventually became part of the Dolphin Motel.

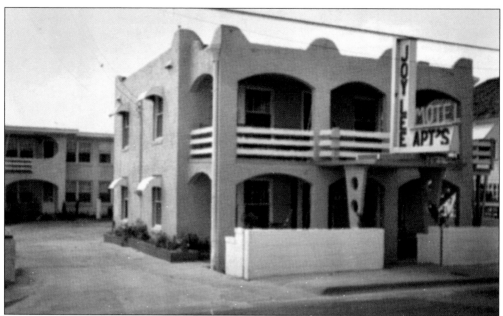

JOY LEE MOTEL AND APARTMENTS. Listed in the National Register of Historic Places in 1997, Grover Lee Lewis built the Joy Lee in 1945; the annex was added in 1948. Built of solid masonry construction, the buildings survived major hurricanes Hazel, Diana, Bertha, and Fran with only minor flooding and roof damage. The railings have changed to hand-cast concrete circles, and the business is still going strong.

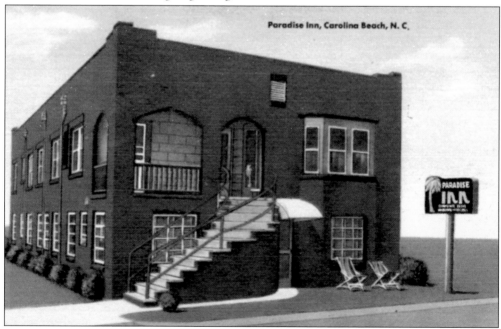

PARADISE INN. Next door to the Joy Lee was the similar-looking Paradise Inn sitting across the street from the ocean in the 300 block of Carolina Beach Avenue North. Leila Mae and Fred Bost operated the inn, whose brick construction also survived Hazel intact. The wooden frame sling chairs out front were very popular in those days.

PARADISE INN MOTEL. Across the street on the oceanfront, the Bosts built modern, two-story accommodations, adding to the original brick Paradise Inn. They were sided with asbestos shingles, used often in those days before the health risks associated with them were known. Nowadays, as many houses on the north end are demolished to make way for new duplexes, special precautions have to be followed for structures with asbestos.

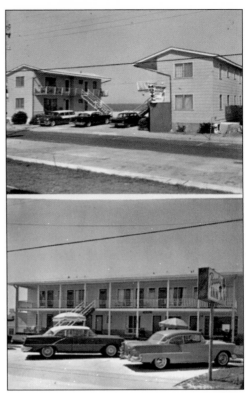

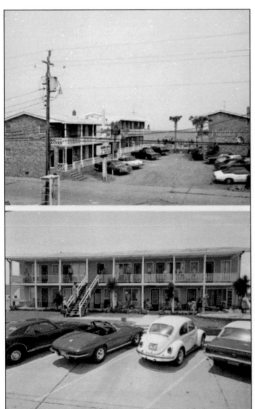

REMODELED PARADISE INN MOTEL. Cars from the 1960s replace ones from 1950s in this chrome card showing the Paradise with brick veneer and some additional rooms. Later a breezeway would connect the two buildings with some Grover Lewis concrete circle railings like those at the Joy Lee, and the original brick building across the street would be replaced with a modern motel. They all met the wrecking ball in the spring of 2006.

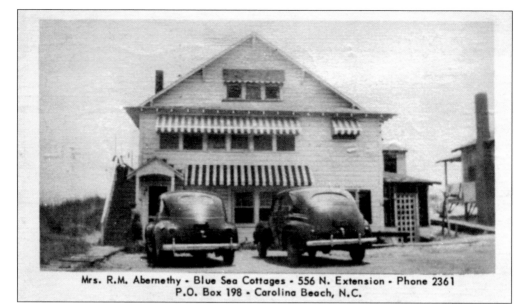

Mrs. R.M. Abernethy - Blue Sea Cottages - 556 N. Extension - Phone 2361
P.O. Box 198 - Carolina Beach, N.C.

BLUE SEA COTTAGES. Mrs. R. M. Abernathy operated this cottage on the northern extension in the 1940s. The address, listed as 556, would be in the 700 block today as the center of town was moved from Harper Avenue to Cape Fear Boulevard, causing addresses on Carolina Beach Avenue North to increase by 200. This cottage was torn down in 2004 and replaced with a modern duplex.

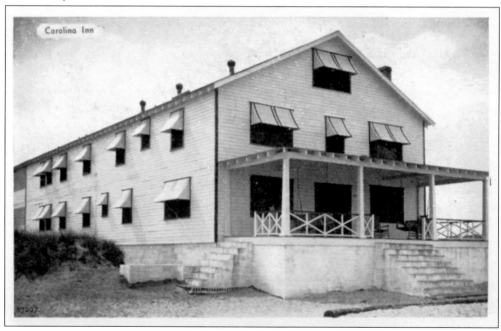

CAROLINA INN. The back of this card lists the address for this inn as 720 Carolina Avenue North, which is in today's 900 block. It was across from the Kupboard Grocery. This view shows the inn from the beachside with a cinder-block foundation and concrete steps up to the porch. Home-cooked meals were served in the dining room; Ira and Katie Burnett Hines once owned it.

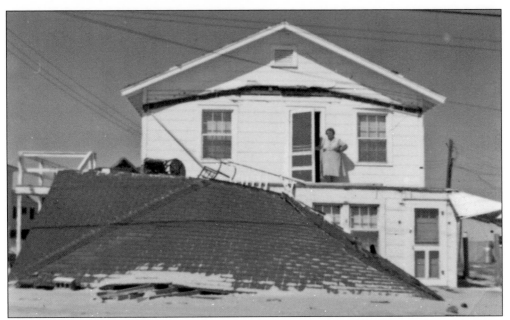

615 CAROLINA BEACH AVENUE NORTH. Jessie L. Lancaster looks out at the roof lying in the street a few days after Hurricane Hazel came through in 1954. She and her husband, L. W. Lancaster, had just decided to buy the 1940 cottage in spite of the two feet of sand in the downstairs apartments and other damage. A few doors down was the Kupboard Grocery, which they operated for many years. (Courtesy of Lank and Genie Lancaster.)

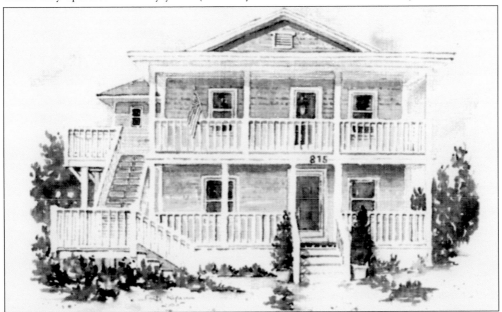

815 CAROLINA BEACH AVENUE NORTH. The Lancasters later had the house put up on a foundation and remodeled the inside. Note the address change, a function of moving the center of town two blocks. They lived in the upstairs and rented the lower level and some apartments on Sandpiper Street. It is one of the few old cottages left on the north end and is still a summer rental.

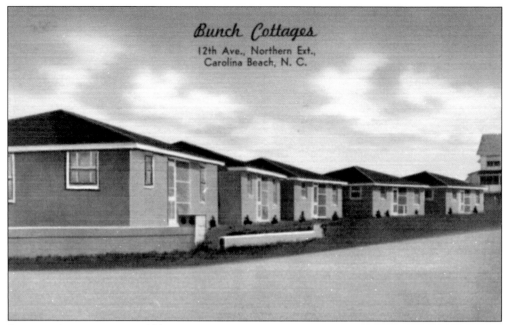

BUNCH COTTAGES. Twelfth Avenue is now Clamshell Avenue, so these sturdy masonry cottages were lined up between Canal Drive and Carolina Beach Avenue North. The cottages each had two bedrooms and a maid's room and were built by Luther Bunch, who owned and operated the Carolina Beach Drug Store at one time.

BUNCH COTTAGES. Though no longer identical, the cottages remained until 2005, when they were torn down to make room for a row of duplexes. The one in the center at some point had a second story added, but the other four remained solidly on the ground, despite seasons of hurricanes and obvious flooding. This vantage point is from the corner of Carolina Beach Avenue North and Clamshell Avenue.

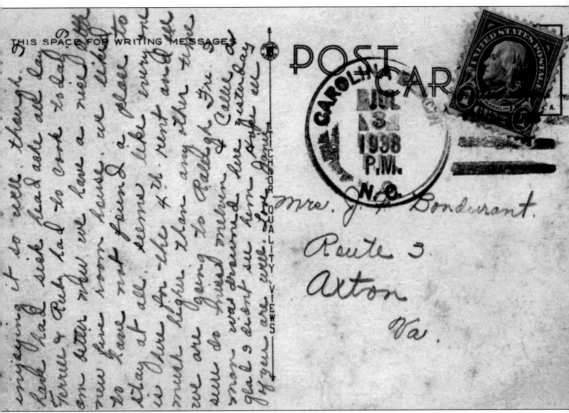

POSTMARKED JULY 3, 1938. Janie, the writer of this card, might well have stayed at one of the Bunch Cottages for the July Fourth holiday in 1938. But she wasn't "enjoying it so well." She had a sick headache one day and wasn't able to cook, leaving that for Ferrell and Ruby to do. They "liked to have not found a place to stay," and when they finally did, the rent was way too high. However, it was nice and new and had five rooms. She misses Callie and Melvin and sure is glad she didn't see the man that drowned yesterday. A postcard that someone wrote and mailed is called postally used and is worth less than a postally unused one. But the used ones certainly are more interesting and give us a glimpse of people's lives in a bygone time. Plus the cancellation stamp helps to date them.

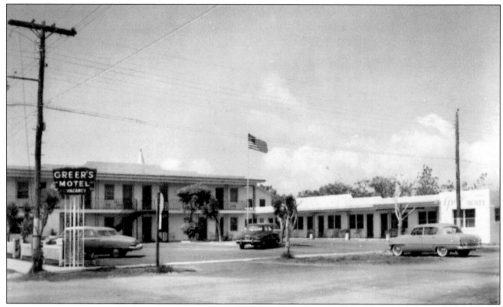

GREER'S MOTEL. Located on Lake Park Boulevard, Greer's was on the corner of that street and Cape Fear Boulevard. It was open year-round and had automatic electric heat, air-conditioning, and Simmons Beautyrest mattresses. Backing up to the motel and facing Lake Park was Greer's Restaurant. Both for sale, the motel is now the Buccaneer and the restaurant is Mama Mia's, a longtime favorite beach eatery.

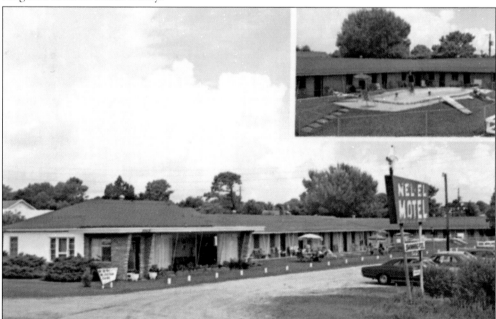

NEL-EL MOTEL. Nell and Elton Woodcock took the first syllables of their first names to make the unusual and hopefully unforgettable name for their motel at 355 Cape Fear Boulevard. It boasted heated, fireproof rooms with showers and luxurious Englander mattresses. It was also air-conditioned and offered optional televisions. In 1959, lifeguard Byron Moore taught swimming lessons in Nel-El's pool. It remains as rooms to rent.

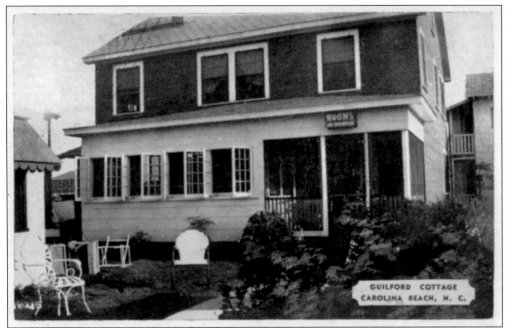

GUILFORD COTTAGE. Dr. and Mrs. S. R. Jordan lived in this cottage with open casement windows on Harper Avenue and rented rooms with hot showers according to the sign over the front door. This card was written by a mother to her son in California in August 1940. A month later, on September 19, the devastating boardwalk fire would begin in the early morning hours, destroying many businesses and two houses.

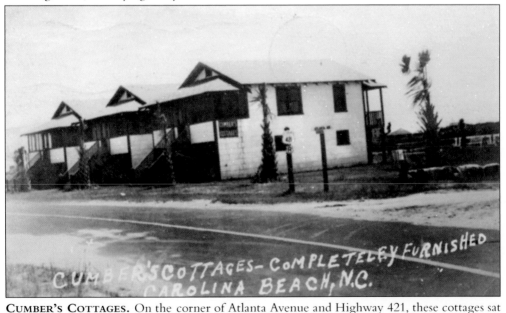

CUMBER'S COTTAGES. On the corner of Atlanta Avenue and Highway 421, these cottages sat across the street from other Cumber's Cottages. The writer says simply, "Heading home;" the postmark is August 11, 1954. Two months later, on October 15, Hazel, the only category four hurricane to hit the area in all of the 20th century, came in on a full moon and lunar high tide, leaving one cottage in the lake.

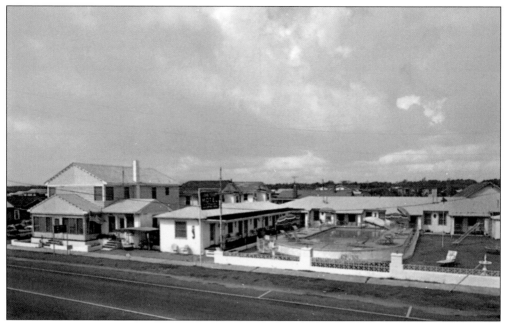

JOHN FERGUS MOTEL AND COTTAGES. Located just one block from the ocean and amusements, this 30-unit motel was on Lake Park Boulevard near Hamlet Avenue. The low concrete block wall out front held up well to hurricane winds and water. Walls like this could be seen all over the beach and were used like fences. They are quickly disappearing, but a few examples can still be found.

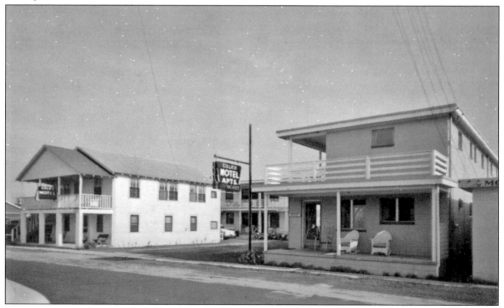

COLE'S MOTEL AND APARTMENTS. Arabella and John W. Cole were the owners and operators of this motel at 244 Raleigh Avenue, conveniently located behind the bus station. She had apartments with two to six bedrooms, but you would have to watch television in the lounge. This chrome card was published by John Kelly, a prominent photographer in Wilmington whose studio was at Third and Greenfield Streets next to Block's Shirt Factory.

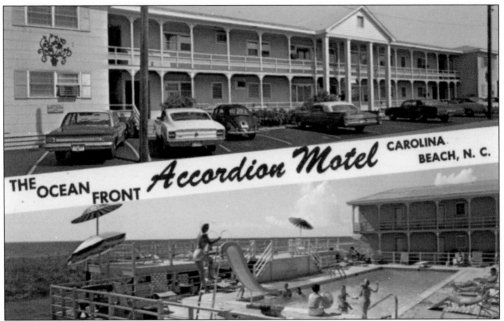

THE ACCORDION MOTEL. The 1965 phone book lists the address for this motel as 102 Carolina Beach Avenue South. John William Washburn loved to play his accordion on the front porch and decided to name his motel for this unusual feature; visitors wouldn't forget the name or his nightly serenade. Serving as mayor from 1959 to 1961, he later sold the Accordion to Ree and Jackie Glisson.

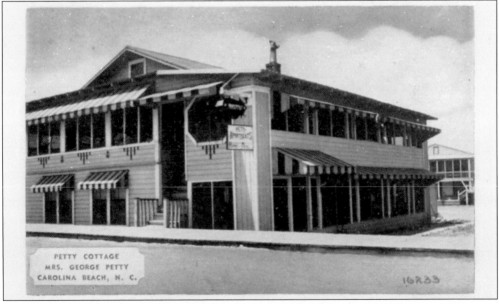

PETTY COTTAGE. Also on Carolina Beach Avenue South and across the street from the Accordion was the Petty Cottage. It had rooms, apartments, and, best of all, home-cooked meals. The striped awnings, very beachy back then, shaded the screened porches and windows from the hot summer sun. The back of this card stated that the Pettys "take personal interest in guests."

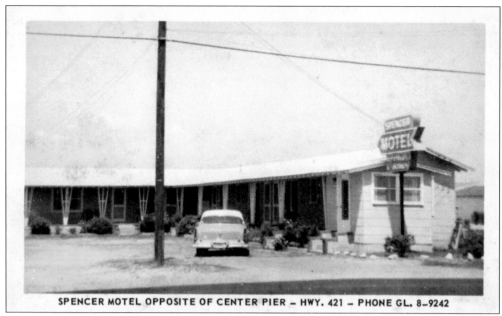

SPENCER MOTEL OPPOSITE OF CENTER PIER – HWY. 421 – PHONE GL. 8-9242

SPENCER MOTEL. After automobiles became the major mode of transportation, motorists liked being able to drive right up to the door of their rooms. That's how motels like the Spencer came to be. The motel was on Highway 421 in what was then Wilmington Beach and across from the Center Pier. It must have been a popular place for fishermen when the spots were running in the fall.

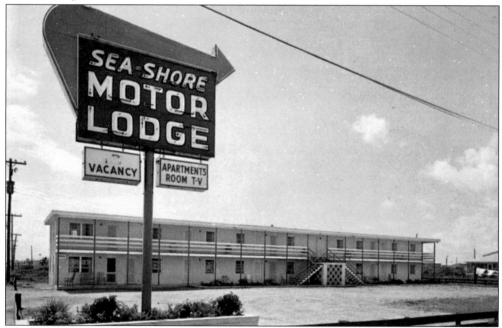

SEASHORE MOTOR LODGE. This motel was also on Highway 421 South and across the street from the ocean. It was obviously off-season when this picture was taken with not one car in the parking lot. On the far right, a clothesline is barely visible; hanging out clothes is practically obsolete in today's world.

STOP-N-REST MOTEL. From 1952 to 1966, the E. E. Worrell family ran this oceanfront motel, which was conveniently located next door to their house. During Hazel, a piling from Center Pier rammed through the back of the concrete-block house, sending the family to live in the motel for several months while repairs were made. The property was located near the entrance to Carolina Sands.

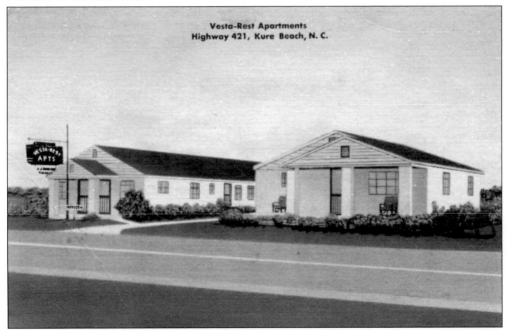

VESTA-REST APARTMENTS. Doris Bame mailed this card from Kure Beach to her father in China Grove, North Carolina, during the summer of 1954. He had to go back home for work after spending the weekend with his family, who remained at the beach. Doris would later marry a Carolina Beach boy and become a permanent resident. Vestus and Jesse Mohn ran the Vesta-Rest, which was a block from the Kure Pier. (Courtesy of Doris Bame.)

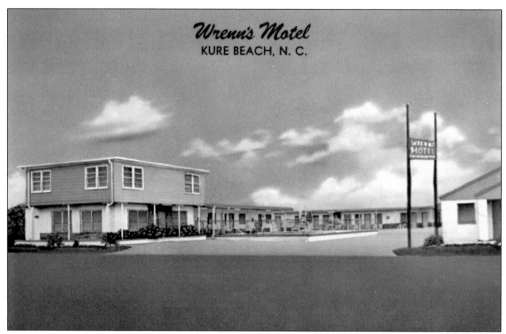

WRENN'S MOTEL. Oscar Wrenn operated this motel with 21 units, which included rooms, apartments, and cottages. It was in the block south of the Kure Pier. Later Norris and Faye Teague ran it as the Sand Castle Motel. Its proximity to the pier made it popular with fishermen who used to clean fish in the bathtub and stop up the plumbing. It was demolished in 2005.

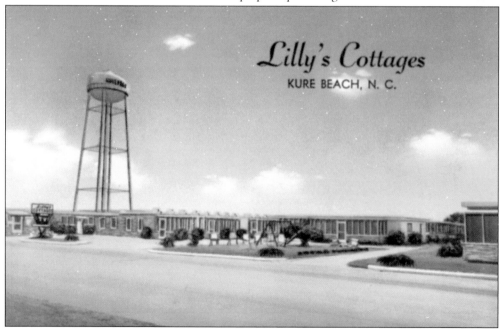

LILLY'S COTTAGES. Faye and David P. Lilly came from High Point and lived in a mobile home on the property while David built the motel and a cottage for his family. Kure's water tower was located in the block north of the K Avenue stoplight, and so was Lilly's. The water tower has moved, and Lilly's is now the Palm Air Inn. (Courtesy of Wayne Bowman.)

Five

BOATS, PIERS, AND FISHING

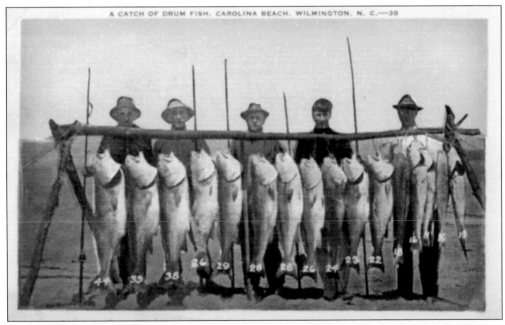

A CATCH OF DRUM FISH, CAROLINA BEACH, WILMINGTON, N. C.—38

A CATCH OF DRUM FISH. An 1891 edition of the *Wilmington Weekly Star* reported that a fishing chair was rigged to a cable so that anglers could sit and ride out 200 yards over the wrecks of blockade runners to fish for sheephead at Carolina Beach. Whether fishing from a chair, a pier, a boat, or standing in the surf, "catching the big one" draws thousands each year to its shores. There won't be any fish stories for the proud fishermen in this postcard; they have a picture to prove how successful they were, replete with the weight of each drum.

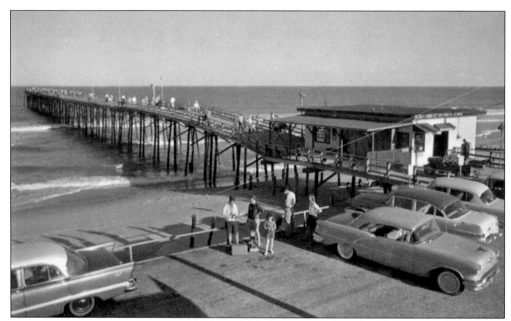

KURE PIER. Built in 1923 by Lawrence Kure, the Kure Pier was one of the first piers on Federal Point. For pilings, he cut trees from forests along the Cape Fear River, but within one year, wood-boring shipworms caused the pilings to collapse. Not to be outdone, Kure rebuilt the pier, this time with reinforced concrete supports with inner cores of steel made from molds he designed.

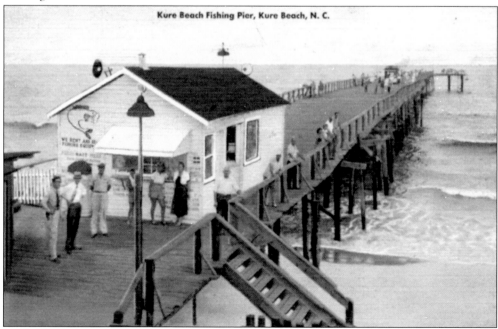

KURE BEACH FISHING PIER. Lawrence Kure is dressed in a tie and hat, maybe to conduct town business since he was Kure Beach's first mayor in 1947, after the town became incorporated. In 1954, Hurricane Hazel destroyed 35 buildings at Kure Beach and the Kure Pier, which had to be rebuilt yet another time.

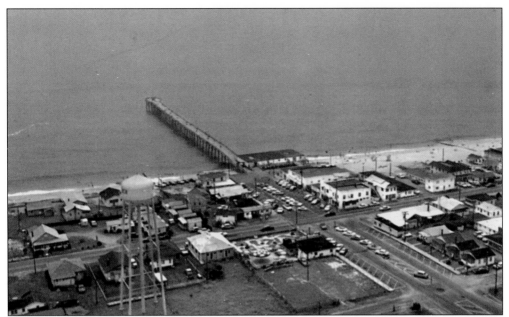

KURE BEACH, NORTH CAROLINA. The famous Kure Pier extends 950 feet into the Atlantic at the end of K Avenue in this chrome card. It was along this route that the Kure Land and Development Company built a little railroad from the river to the sea on which they hauled all the materials for a two-story bathhouse in 1915 and later for the pier and other buildings.

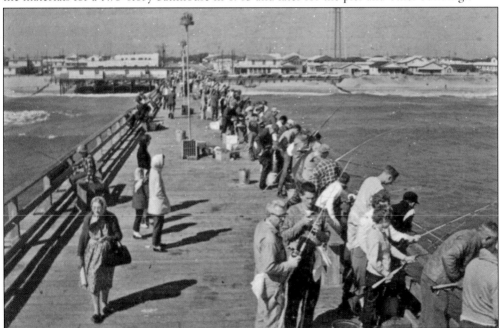

BILL ROBERTSON'S KURE PIER. In 1952, Lawrence Kure sold the pier to his daughter Jennie and her husband, Bill Robertson. A colorful character and beach promoter, Robertson coined the phrase "Man! You should have been here last week!" and even wrote a book by that title full of fish stories. Mike Robertson, of the third generation, currently operates this beach landmark.

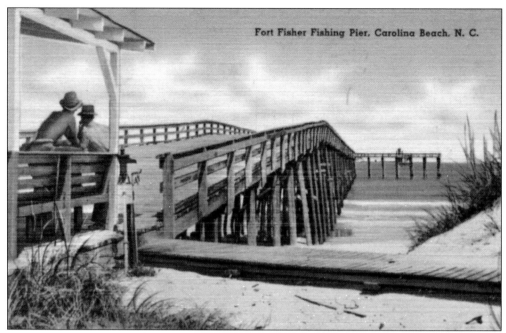

Fort Fisher Fishing Pier, Carolina Beach, N. C.

FORT FISHER PIER. Walter Winner, Carl Winner's brother, built this pier in 1936 at Fort Fisher for brothers Louis and Thomas Orrell. Later an extension was built parallel to the shore as a loading ramp for a bottom fishing boat. The extension was also over the wreck of the *Modern Greece*, a sunken blockade runner. In 1946, one could fish this pier for 24 hours for 35¢.

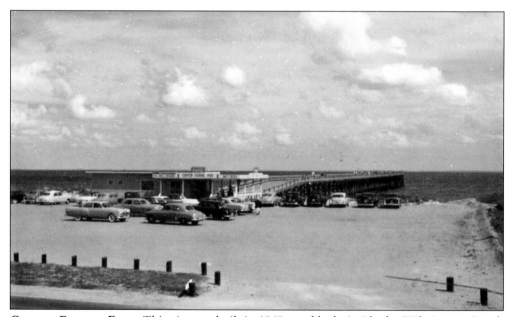

CENTER FISHING PIER. This pier was built in 1949 two blocks inside the Wilmington Beach limits; five years later, it went down in Hurricane Hazel. This card, postmarked in 1958, shows the rebuilt pier, the Ocean View Restaurant, and a sandy parking lot. It remained until Hurricanes Bertha and Fran took most of the pier in 1996; what remains is now a tiki bar.

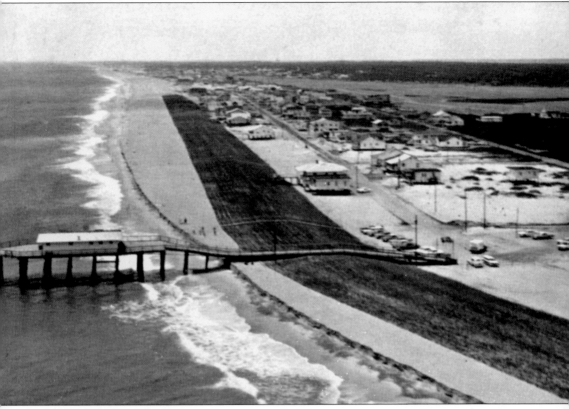

CAROLINA BEACH PIER. This pier, nicknamed the North End Pier, was constructed in 1946 at the far end of the northern extension. The original pier was destroyed by Hurricane Hazel in 1954 and rebuilt. At the time of this photograph, the pier house was built over the ocean, unlike the present one, which is on land. Fisherman used to come in travel trailers and park in a nearby lot, since the accommodations at that end were scarce. Also visible is the end of Carolina Beach Avenue North turning into Salt Marsh Avenue, both unpaved. In the distance is the canal and Canal Drive, which was also not paved. Efforts of early beach renourishment are easily seen with a wide strip of sea oats planted in 1965 by Southern Seeding, who came in with the lowest bid of $47,404. Today this area of beach has eroded within a few yards of the oceanfront houses, and there is a row of rocks from the pier past Sand Fiddler Avenue, some two and a half blocks.

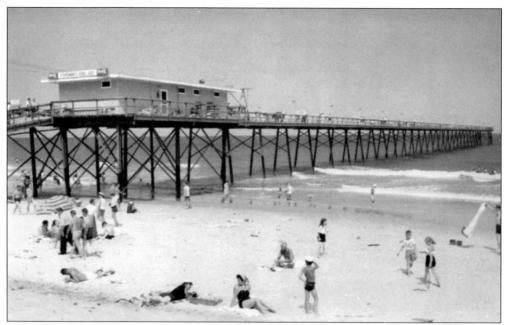

FISHERMAN'S STEEL PIER. By 1955, when this pier was built at the end of the boardwalk, the owners chose to build it with steel reinforced pilings. Appropriately, it was always known as "the steel pier." It extended 1,000 feet into the Atlantic Ocean and was 24 feet wide. Beachgoers loved to spread their blankets nearby; there was full sun or shade under the pier.

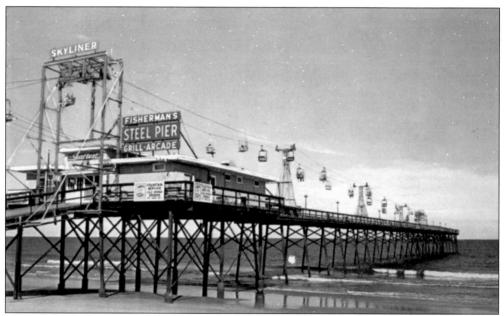

SKYLINER RIDE. Later a cable car ride over the pier was added to attract throngs of visitors, not just fishermen, to the boardwalk. It was billed as one of the most unique rides on the Carolina coast. The ticket price for a ride was 50¢ for adults and 35¢ for children.

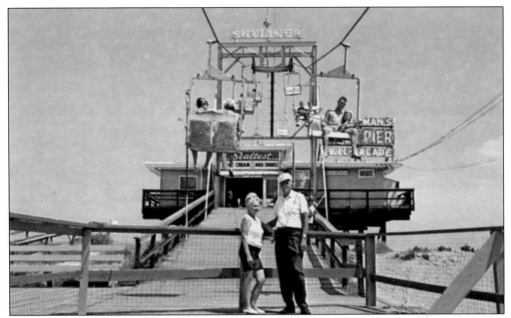

SKYLINER. The Howard McGirts are standing at the entrance to the Skyliner in this chrome card with riders overhead. In response to a 1970s idea of replacing the boardwalk with a modern, three-story hotel-entertainment complex, Howard was quoted as saying, "It would be a dream, and I would stay at Carolina Beach. Otherwise, I'm going back to Raleigh and sit under the apple tree."

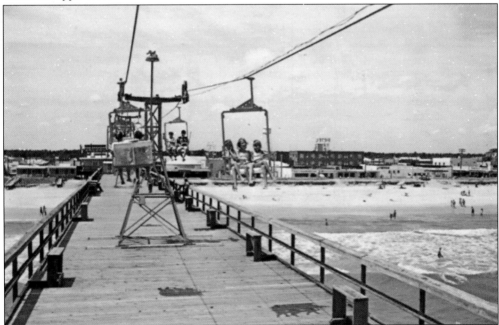

SKY RIDE OVERLOOKING THE BEACH. The writer of this card, postmarked in 1971, may well be one of the riders getting a wonderful view of the ocean on the ride out and views of the boardwalk on the ride back. In the background on the right is Hotel Bame, and the top of the Ocean Plaza is visible behind the boardwalk amusements.

77

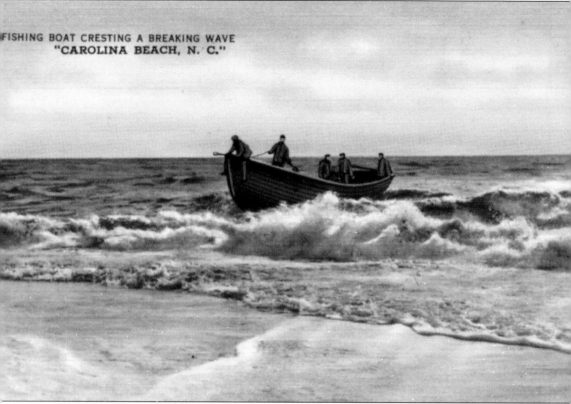

FISHING BOAT CRESTING A BREAKING WAVE
"CAROLINA BEACH, N. C."

FISHING BOAT. Before the present canal was dredged to make a yacht basin in 1939, boats had to come and go through the breakers. The fishermen in this linen card are probably part of the Freeman family from Seabreeze. They launched their boats each morning at sunrise, and after fishing at a secret spot all day, they returned with their catch in the afternoon. Having only one motor, three boats were tied together—one pulling the other two. Fred Block used to go with his mother in the 1930s to buy fish from the Freeman brothers on the beach. He would swim out with others and help the boats come in through the crashing waves. Once the boats were ashore, customers would grab for bunches of fish tied with sea oats. They were mostly black bass with some redmouth, pigfish, croaker, trout, spot, and treasured flounder. The bunches of two to four fish sold for 25¢. The price included cleaning—or dressing, as it was called in those days—done on the spot.

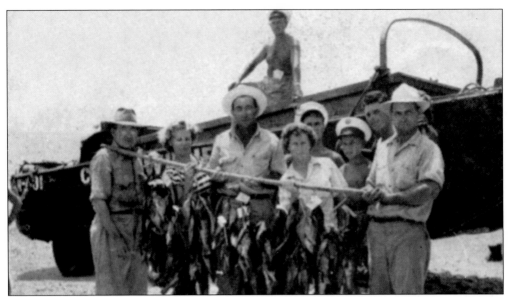

AMPHIBIOUS DUCK. At the southern end of the boardwalk, Carl Winner Sr.'s crews took parties in surfboats with outboards through the breakers to anchored head boats offshore. The surfboats would go out and come in on the hour, ferrying fishermen and fish. Having no facility to fuel up, they also took fuel to the head boats, five gallons at the time. They filled up containers at Bame's or Knox's filling stations at the end of Cape Fear Boulevard for this task. Some head boats had four tanks that held 35 gallons each, so it took a lot of trips to keep them fueled. After World War II, Winner bought army surplus amphibious ducks to ferry his passengers. He is seen standing in one at the top of this picture. Young Carl Winner Jr., known as "Skippy," is the young man wearing a captain's hat third from the right. They kept tickets under their hats so they could sell them anytime. Skippy's sisters used to sell them on the boardwalk during their summers home from college. (Courtesy of Albert Jewell.)

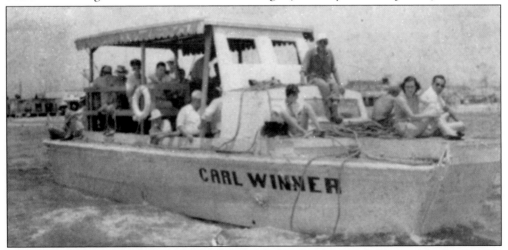

CARL WINNER. This boat was a surplus World War II, 40-foot landing craft with a fold-down front. Though "Carl Winner" is on the side, its name was actually *Sailor's Choice*. Clever marketing had every boat in the Winner fleet with the Winner name on it in big letters in addition to its registered name. Some of their other boats were *Supersonic, Lollypop, Fish Hook, Ocean Lady, Mars,* and *Sphinx.* (Courtesy of Albert Jewell.)

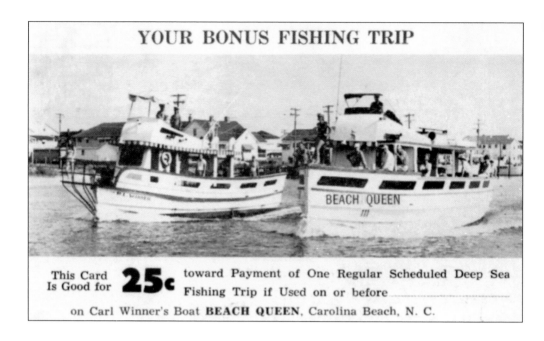

YOUR BONUS FISHING TRIP

BEACH QUEEN

This Card Is Good for **25¢** toward Payment of One Regular Scheduled Deep Sea Fishing Trip if Used on or before _____

on Carl Winner's Boat **BEACH QUEEN**, Carolina Beach, N. C.

BONUS FISHING TRIP. Another marketing strategy used by the Winners was this combination discount ticket and postcard. It was good for 25¢ off a $5 fishing trip. They also gave a 50-percent discount to all servicemen, firemen, and policemen. On the left was the *M. L. Winner*; the one on the right was the *Beach Queen*. Most of the Winner fleet was military surplus boats rebuilt by the family. In July 1961, a couple by the names of Walt and Trisha went deep-sea fishing with the Winners and used the discount ticket as a postcard, mailing it to his dad in Burlington. (Courtesy of Albert Jewell.)

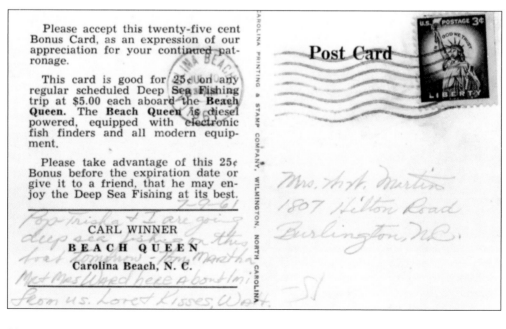

Please accept this twenty-five cent Bonus Card, as an expression of our appreciation for your continued patronage.

This card is good for 25¢ on any regular scheduled Deep Sea Fishing trip at $5.00 each aboard the Beach Queen. The Beach Queen is diesel powered, equipped with electronic fish finders and all modern equipment.

Please take advantage of this 25¢ Bonus before the expiration date or give it to a friend, that he may enjoy the Deep Sea Fishing at its best.

CARL WINNER
BEACH QUEEN
Carolina Beach, N. C.

Post Card

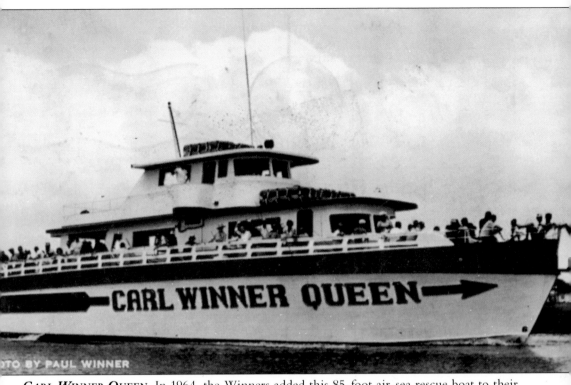

CARL WINNER QUEEN. In 1964, the Winners added this 85-foot air-sea rescue boat to their fleet. Capt. Skippy Winner ran it seven days a week, introducing Gulf Stream fishing to Carolina Beach. It carried up to 150 passengers and a crew of 10. Sold in the 1970s to a buyer in Alaska, the boat encountered a storm before reaching the Panama Canal and was lost. Paul Winner, who took this photograph, was Skippy Winner's cousin and photographed boats and fishing tournaments all along the East Coast.

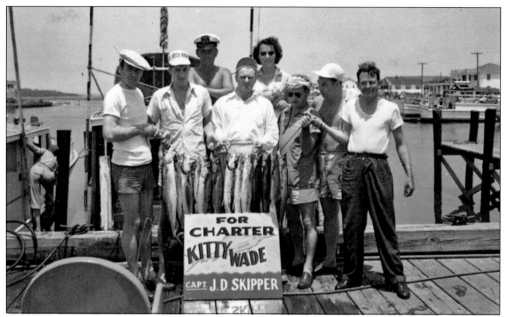

FISH CATCH. This proud group of anglers displays their catch after being out with Capt. J. D. Skipper on the *Kitty Wade*. There were many deep-sea fishing charter boats to choose from at the municipal yacht basin on King Street; in 1982, the street was renamed Carl Winner Avenue for the grandson of one of the town's founding fathers, Joseph L. Winner.

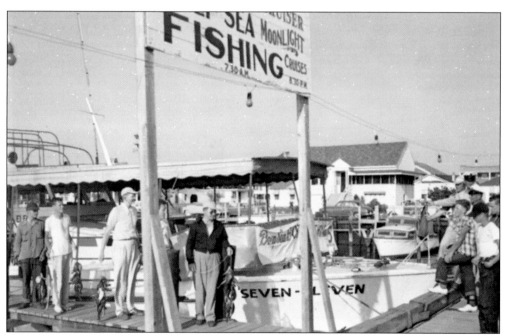

SEVEN ELEVEN. A former PT boat, the *Seven Eleven* is docked at the yacht basin after a day's fishing. It would take fishing parties out to the Gulf Stream for $5 a day, leaving the dock at 7:30 a.m. In the evenings, they would go back out for midnight cruises. Notice the string of light bulbs across the front of the dock and Canal Drive houses in the background.

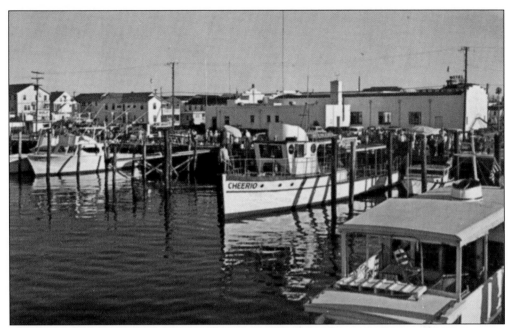

CAROLINA BEACH YACHT BASIN. The Batson brothers' *Cheerio* and other charter boats sit ready for a day of fishing in this chrome card from the 1960s. The boat in the bottom right hand corner is the *Comandress*; more information on this can be found on page 85. The scene is facing Carl Winner Avenue, with the Municipal Building in the background.

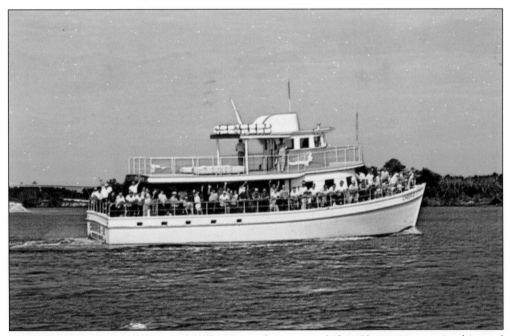

CHEERIO II. Captains Doug and Billy Batson later owned the *Cheerio II*, seen in this card postmarked July 19, 1969. This *Cheerio*, 65 feet long and with three diesel engines, is headed to the Intracoastal Waterway with a large group of passengers, some waving to the camera. In the left background is the new high-rise concrete bridge over Snow's Cut, completed in 1963.

83

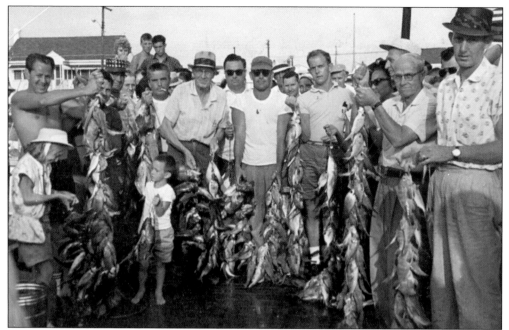

DAY'S CATCH. A proud group of fishermen is showing off their catch after a day of deep-sea fishing. Every afternoon in the summer season, people gather at the yacht basin to watch the boats come in with their treasures from the deep. The fishermen love to tell stories of their conquests at sea, and the dock visitors love to listen.

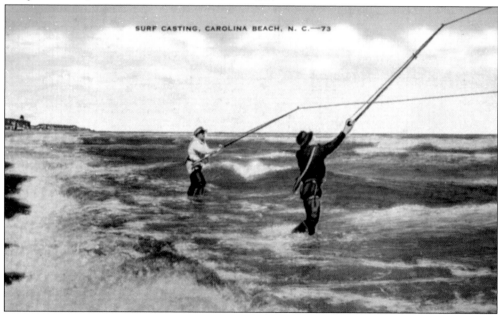

SURF CASTING, CAROLINA BEACH, N. C.—73

SURF CASTING. Not all fishermen practice their sport from a boat or pier. Many are devoted to surf fishing, as the two seen in this card postmarked June 13, 1944. A Fort Bragg soldier on leave at Carolina Beach mailed it to his parents in New Jersey. In the stamp space, he had written, "FREE." During World War II, free postage was a small perk for those serving our country.

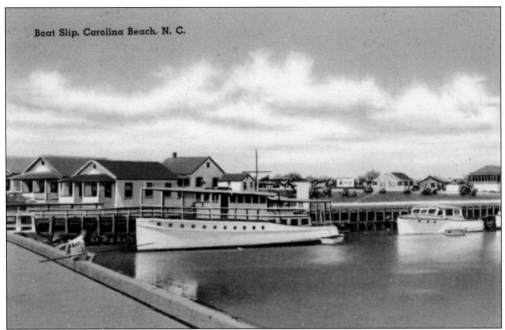

Boat Slip, Carolina Beach, N. C.

BOAT SLIP AND MOTOR BOAT RIDE. A young man sits on the edge of the yacht basin with his fishing pole trying his luck. He also may have admired the *Comandress*, a 60-foot yacht tied up to the dock. It was owned by a jeweler from Burlington named Pete Neese. He had a handlebar mustache and by all accounts was quite a character. He was known to fly a flag with the letter P on it to signify his wife being away; the P stood for the peace he enjoyed in her absence. When she was on board, he flew a flag with a battle-ax—no comment needed on that flag. The *Comandress* can also be seen in the background of the card at the bottom with another classic boat out for a ride.

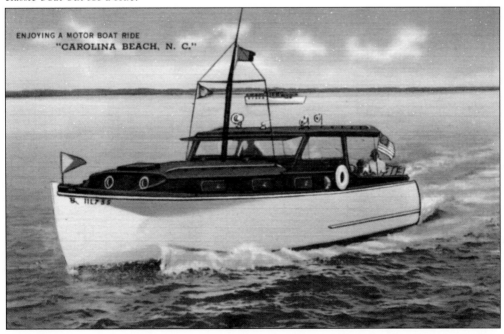

ENJOYING A MOTOR BOAT RIDE
"CAROLINA BEACH, N. C."

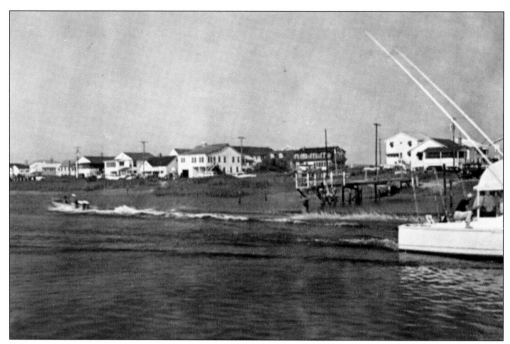

BOATING IN THE CANAL AND SPEEDBOATING. Bill Bost is in the small boat with two outboards speeding north in the canal. With his trademark white captain's hat and ever present cigar, his was a familiar face around the beach. He not only introduced waterskiing to Carolina Beach but also taught the skill and made skis as well. In the 1950s, he was responsible for bringing the famed Cypress Garden Team here for shows. In the bottom card, Capt. Joe Kelly is at the wheel of his speedboat taking some lucky passengers for a ride. Kelly's Speed Boats were for hire at the yacht basin for years.

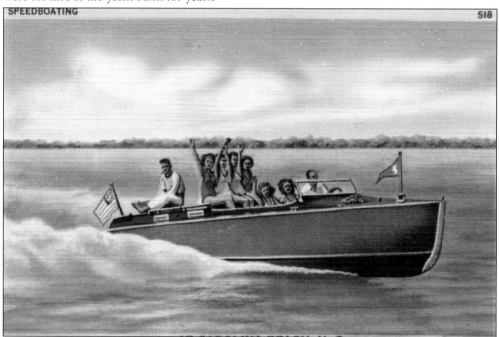

SPEEDBOATING

S18

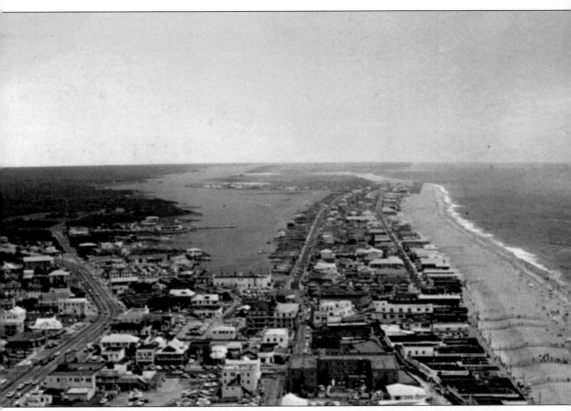

AERIAL VIEW, BEACH AND YACHT BASIN. The back of Bame's Hotel and the other buildings on Cape Fear Boulevard are easily seen in this view of the town looking north. On Harper Avenue are the Royal Palm Hotel and a large parking lot where the Fountain Apartments used to be; the Fountain family owned both. The apartments were sold and moved in 1959. Looking farther north is the side of the Municipal Building, which faced Canal Drive. Also seen are the head of the canal and the yacht basin. Early in 1939, the town bought six acres at a price of $5 per acre in order to build the yacht basin. A total of 15 cannon balls were dug from the site during the dredging process, which was completed by June of that year. Plans were then made for the construction of a wharf and a boardwalk at the basin and a new street called Canal Drive.

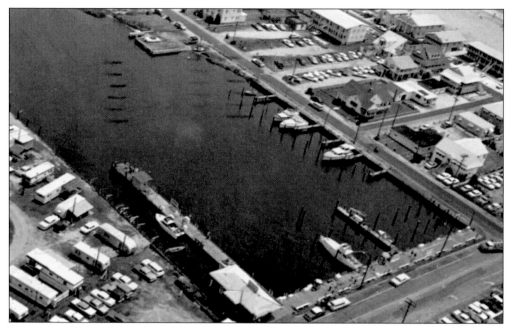

YACHT AND BOAT BASIN. Most of the boats are out for a day of fishing in this 1966 postmarked card of the yacht basin. Also shown are a paved Canal Drive and Pelican Lane connecting to Carolina Beach Avenue North. In the bottom left corner are a group of trailer homes with a wonderful view. The town outlawed mobile homes in this area in 1972, but existing ones were allowed to stay.

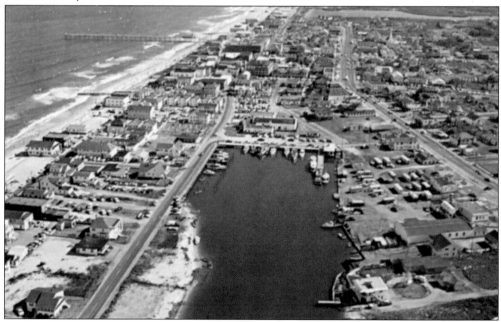

AERIAL VIEW, BOAT BASIN. Postmarked in 1961, this card shows the yacht basin, also called boat basin, looking south. Landmarks include the Municipal Building, Royal Palm Hotel, the Fisherman's Steel Pier, and Hotel Bame. Across Lake Park Boulevard near the Carolina Beach Lake, the Presbyterian church and its steeple are barely visible.

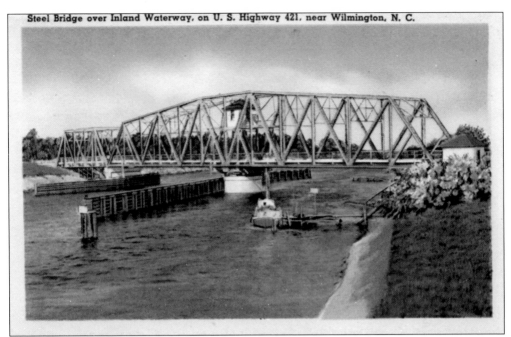

STEEL BRIDGE. This swing bridge opened in August 1931 over Snow's Cut, a section of the Intracoastal Waterway. The Army Corps of Engineers completed the cut in April 1930, connecting Myrtle Grove Sound and the Cape Fear River and making the Federal Point peninsula an island. The steel bridge replaced a temporary wooden bridge used during the digging, which was burned when no longer needed.

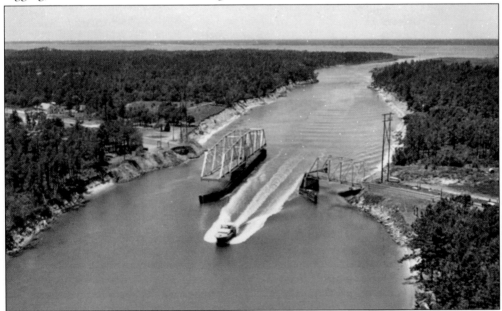

DRAWBRIDGE. A boat speeds through the open swing bridge in this Hugh Morton photograph postcard. The names "draw" and "swing" were used interchangeably to describe this bridge, even though their meanings differ. The Cape Fear River is seen at the top of this card with the land to the left being the Carolina Beach side of Snow's Cut.

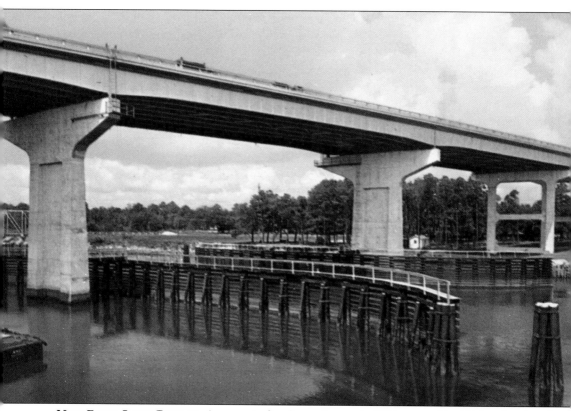

NEW FOUR-LANE BRIDGE. A concrete fixed span, begun in 1961, opened in 1963 and replaced the steel drawbridge. The steel bridge can still be seen on the far left of this chrome card. The newer one is 65 feet above Snow's Cut and put an end to the long traffic lines on both sides when the swing bridge was open.

Six

THE BOARDWALK

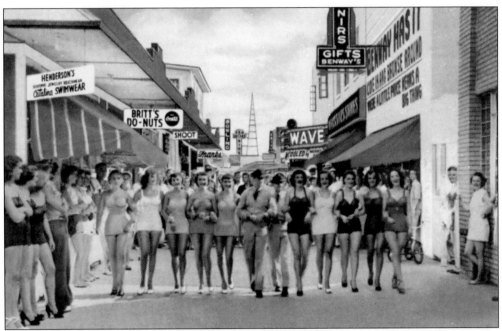

BEAUTIES ON PARADE. One can only imagine how proud these two lucky soldiers must feel marching down the boardwalk with a line of bathing beauties on each arm. During and after World War II, Carolina Beach's boardwalk was a popular place for servicemen to spend leave. The many attractions, including Benway's Souvenirs and Gifts, the Wave Theater, Frank's, the Shooting Gallery, the famous Britt's Donuts, and Henderson's Beach Shop, are seen along the sides. In later years, this part of the boardwalk became concrete; the real, wooden one remained behind the buildings on the right along the beach strand.

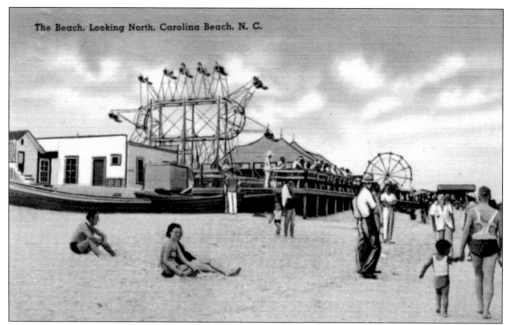

The Beach, Looking North, Carolina Beach, N. C.

THE BEACH, LOOKING NORTH. The roof of the pavilion can be seen in the background of this linen card from the 1930s. The wooden surfboats on the sand probably belonged to Carl Winner and were used to ferry passengers back and forth to larger fishing boats anchored offshore.

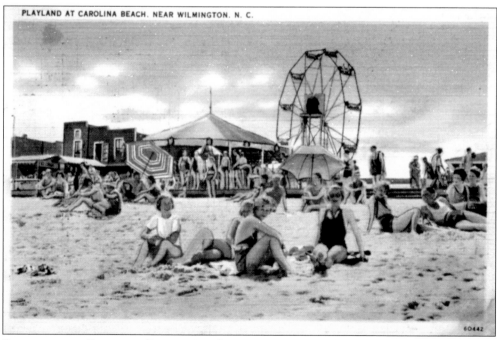

PLAYLAND AT CAROLINA BEACH, NEAR WILMINGTON. N. C.

PLAYLAND AT CAROLINA BEACH. Beachgoers are sitting on their blankets enjoying the sun and ocean breezes. Not so worried about skin cancer and damage from the sun in those days, just a few of them are under umbrellas. The Ferris wheel and merry-go-round were actually farther back from the strand than the ones in this card.

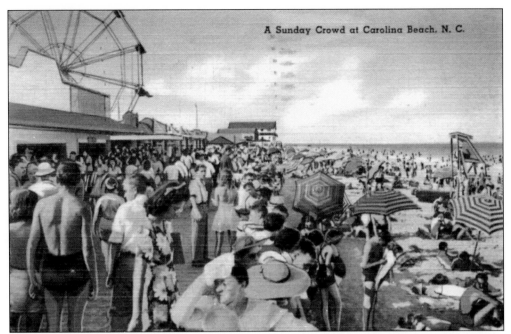

A Sunday Crowd at Carolina Beach, N. C.

SUNDAY CROWD. Sunday was a popular day for people to take a drive to the beach and see the sights; some are still in their church dresses and hats. Vance Henson went to Carolina Beach on a summer Sunday in 1947 and met his future wife, Lucille Latta, who was vacationing from Durham. He was dressed to the nines in a three piece suit, and she was wearing a bathing suit.

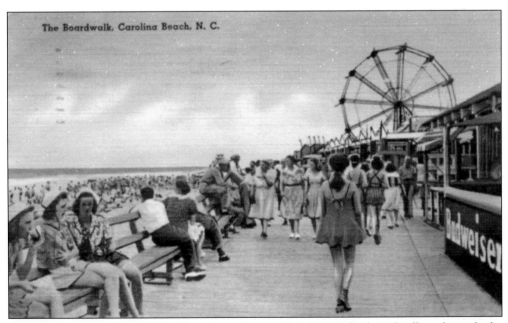

The Boardwalk, Carolina Beach, N. C.

THE BOARDWALK. People loved to sit on the benches lining the boardwalk and watch the world go by. The writer of this card is from Minnesota and writing to her brother back there states that she has had "my first and probably my last view of the ocean. It is simply wonderful." Like most first timers to the beach, she also had a sunburn.

93

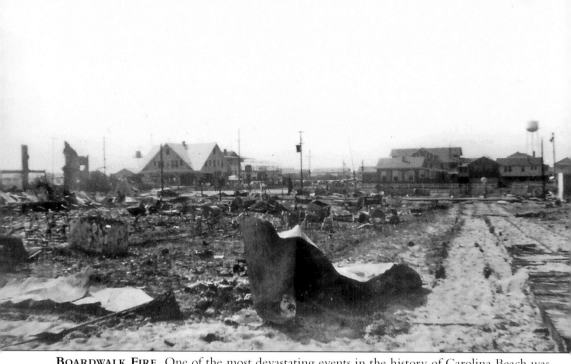

BOARDWALK FIRE. One of the most devastating events in the history of Carolina Beach was the boardwalk fire that started in the pavilion in the early hours of September 19, 1940. This photograph shows the charred remains of many buildings with the Bame Grocery and Filling Station (present day Sterling Craft Mall) still standing; the Bame Hotel, however, burned to the ground. Two solid blocks of the business section and midway were lost in a matter of hours. A *Wilmington Star* news article listed the buildings destroyed: Carolina Café, ABC Store, Palais Royal, Carolina Beach Theater, A&P Grocery, Walsh's Bingo, Plummer's Store and home, Peay's Souvenir Stand, Sam Wright's Shooting Gallery, Peay's Café, Peay's Barber Shop, Coastal Grill, Ocean Front Grill, Bingo Stand and Bowling Alleys, Green Lantern, Joy Joint Photo Shop, Mrs. John Fergus Gift Shop, Cliff Smith's Grocery, Croom's Souvenirs, Winner's Bath House, Seashore Café, Sell's Bowling Alley, Batson Bathhouse, Schley's Bingo, and the Bame Hotel. A miraculous rebuilding of only brick and concrete block structures took place over the winter months, and by June 1941, the boardwalk reopened with the town being billed as the "South's Miracle Beach." (Courtesy of Frances and Bob Doetsch.)

LITTLE BATHER. In 1952, nineteen-month-old Gary Doetsch poses for the camera at the surf's edge in this shot captured by his mom, Fran. Twelve years before this photograph, Fran's stepfather, Melvin D. Mosley, was the police officer who discovered the 1940 fire at the boardwalk. Bob Doetsch served as a member of the Carolina Beach Town Council from 1981 to 1989, being mayor pro tem the last two of those years. Later Gary would follow in his footsteps and serve two terms on the council, from 1998 to 2005. (Courtesy of Frances and Bob Doetsch.)

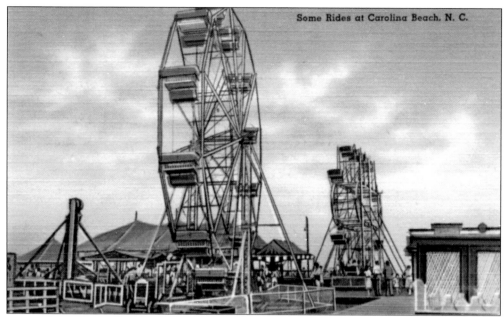

SOME RIDES AT CAROLINA BEACH. Because of the considerable height and size of the Ferris wheel, almost every postcard of the boardwalk shows this ride. It faced the ocean, and at the top, riders felt like they were right over the water and would surely splash in it on the way down. A. L. Mansfield's Amusement Company owned this and other rides at the northern end of the boardwalk, following the carnival circuit in the off-season.

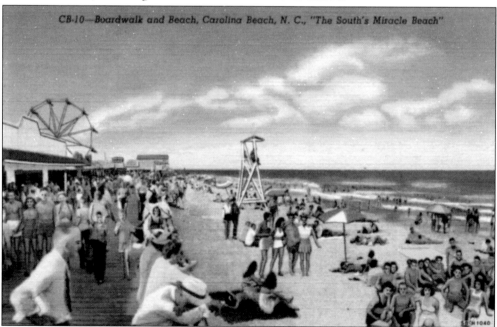

BOARDWALK AND BEACH. There was always a lifeguard stand right in front of the crowded part of the beach, as seen in this card, which was mailed in March 1943. It was written by a young man to his girl back in Greensboro. He wrote that he had been given "the blink" by the army and was now working with a surveying crew at Fort Fisher.

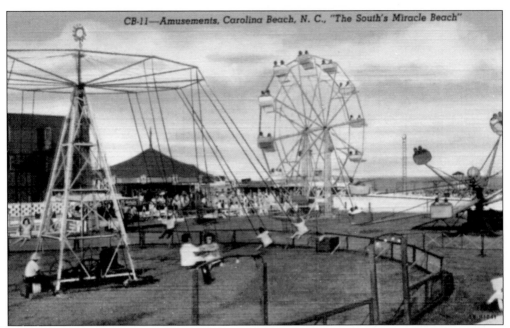

AMUSEMENTS. The boardwalk included a children's playground with an assortment of rides and games. Swings and the tilt-a-whirl were favorites of the smaller set. On the right is the back of the Bame Hotel. From 1916 to 1937, children attended school on the boardwalk in a big room separated into three sections by sheets. The sections housed the fire department, town hall, and the school.

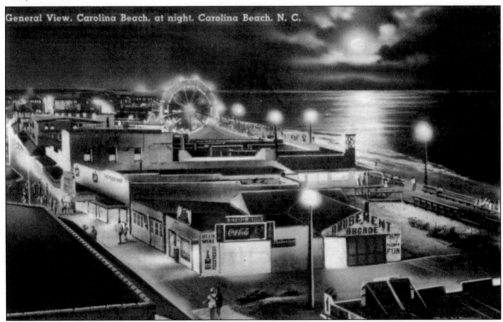

General View, Carolina Beach, at night, Carolina Beach, N. C.

CAROLINA BEACH AT NIGHT. There was something magical about the boardwalk at night all lit up. This card has a good view of the benches along the wooden walkway by the beach and the moonlight shinning over the ocean. All the amusements and eateries overflowed with crowds in the cool night air.

97

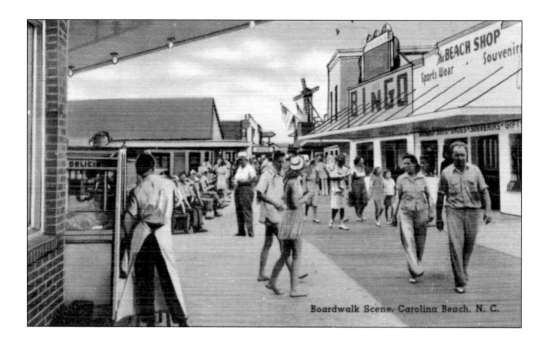

Boardwalk Scene, Carolina Beach. N. C.

BOARDWALK SCENES. Both of these postcards are of the same area of the boardwalk and illustrate how the printers often used artistic license in creating some of the linen cards like the one at the top. It shows the middle building on the right as a bingo parlor next to the Beach Shop, when in actuality, it was the Landmark Restaurant, as seen in the chrome (photograph) card at the bottom. The old saying that a picture is worth a thousand words is certainly true of chrome cards, but you can't always believe what you see in linen ones.

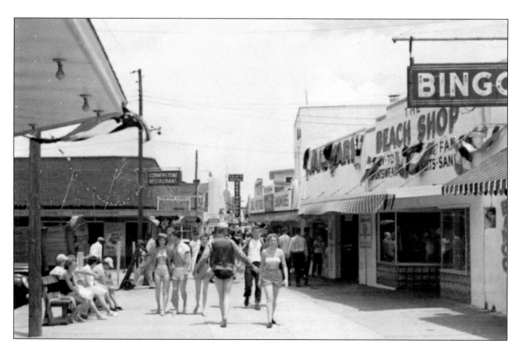

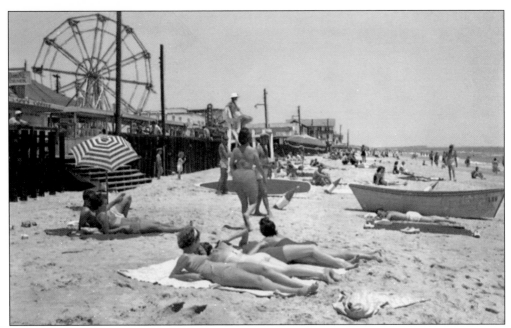

BOARDWALK. The creosote pilings in front of the boardwalk were placed 20 inches apart in the fall of 1947 to protect the boardwalk and break the force of the waves at excessively high tide. Erosion solutions were being explored at that time, but beach renourishment was a couple of decades away. An attentive lifeguard sits on the stand with his long board and lifeboat ready for action if needed.

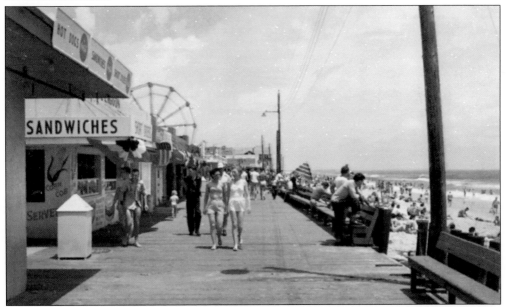

BOARDWALK. Beachgoers stroll past the Red Apple, known for its signature candy apples and hot buttery corn on the cob. Some people loved to watch the machine that pulled saltwater taffy in long ribbons or to eat a "pronto pup," the forerunner of a corn dog. Other boardwalk eateries included the Goldsboro Grill, McLawhorn's, Ocean Grill, Hodges' Grill, Peaches' Place, Peay's Café, Green Lantern, S&S, and Zarna Grill.

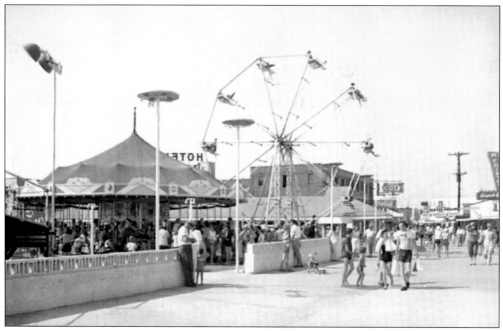

PLAYGROUND AREA. The back of the Bame Hotel can be seen in the background of this card, indicating that this view is south of Cape Fear Boulevard. Beachgoers stroll along the wide walkway past the building with the boats, Ferris wheel, and merry-go-round. A sign for Register's Beach Wear peeks out from the right edge.

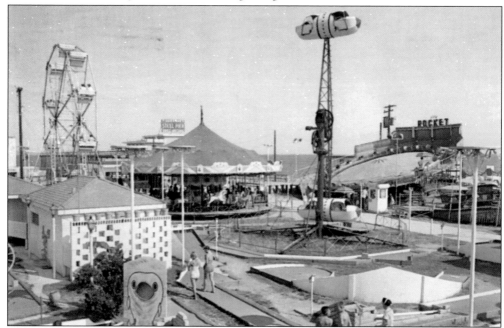

PLAYGROUND AREA. The Fisherman's Steel Pier is in the background of this card of the same scene as above but from a different vantage point. The dolphin with an open mouth seen at the bottom is part of a miniature golf course in front of Blue Waters Court. Other rides on this end are the Bullet and Rocket. It took a 3¢ stamp to mail this in 1961.

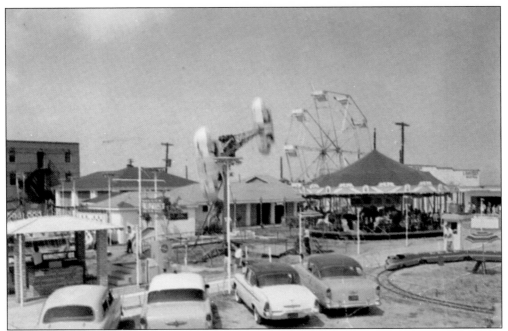

PLAYGROUND AREA. A row of cars is parked right in front of the train ride in yet another view of this end of the boardwalk. These rides were part of Sea Shore Amusements, owned and operated by Adolph and Deloris Kaus. They also owned and lived in Blue Waters Court, pictured on page 51.

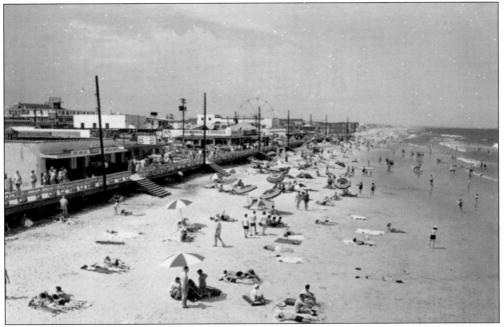

MAIN BOARDWALK. Taken from the Fisherman's Steel Pier, this is a shot of the beach side of the boardwalk. Batson's Bath House is on the far left; next to that is the Winner's Cork and Sinker Bar, and beyond that is the Boardwalk Canteen. The Ferris wheel in the distance was part of Mansfield's Amusements. Just behind it is the side of the Ocean Plaza.

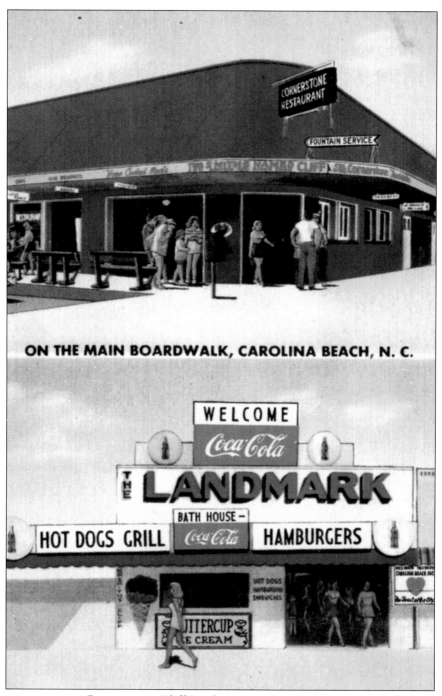

ON THE MAIN BOARDWALK, CAROLINA BEACH, N. C.

WELCOME
Coca-Cola
THE LANDMARK
BATH HOUSE —
Coca-Cola
HOT DOGS GRILL HAMBURGERS

CORNERSTONE AND LANDMARK. Cliff Smith Sr. started a grocery store on the boardwalk in 1932, and it grew into the legendary Landmark, seen on the bottom half of this linen card. The Landmark was a combination grill, novelty shop, ice cream stand, and a family arcade. Later Smith opened the Cornerstone Restaurant across the way; it was nicknamed "Two Smiths Named Cliff" because by then Cliff Smith Jr. was helping his dad with the business. The last Landmark, with different owners, closed in 2005.

Seven

THE BEACH

PLAYING IN THE SAND, CAROLINA BEACH, N. C.—80

PLAYING IN THE SAND. Everyone enjoys watching children—like these little girls with their metal sand pails—play in the sand. Sand, sun, and the ocean are the lures that have been bringing people to Carolina Beach for over a century. In 1949, the writer of this card vacationed at Kure Beach in October, a favorite time for many.

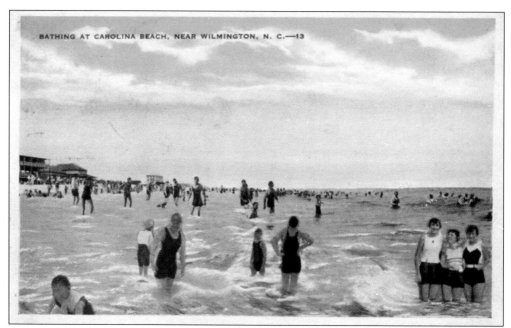

BATHING AT CAROLINA BEACH, NEAR WILMINGTON, N. C.—13

BATHING AT CAROLINA BEACH. Both of these white-border cards show early bathers in the ocean and playing in the sand. In the background to the left are the pavilion, a concession stand, and the Ocean View Hotel. It is very likely that many of the figures have literally been cut from real photographs and pasted on another photograph as a way of adding interest to the composition of these cards. Some of these beachgoers may have seen daredevil Jimmy Calhoun of the Bugs McGowan Flying Circus overhead in June 1923. From a plane flying over the beach, he hung from his heels and did some wing walking and other tricks. He lost his life in July of that same year when his plane plunged into the surf at Isle of Palms, near Charleston, South Carolina.

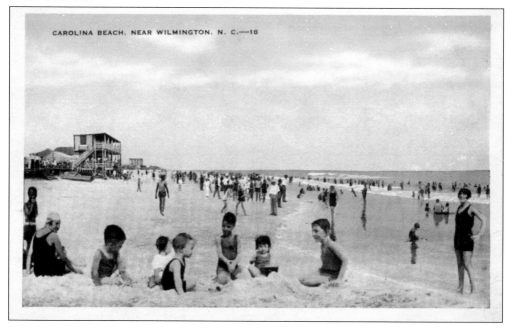

CAROLINA BEACH, NEAR WILMINGTON, N. C.—18

MOONLIGHT BATHING. Wilmingtonian Louis T. Moore took the photograph at the top of this page. In his job as director of the chamber of commerce, he took hundreds of photographs of Wilmington, Wrightsville, and Carolina Beaches and the surrounding areas in the 1920s and 1930s. Many were selected to become postcards. For those, possibly Moore himself wrote the names of colors over the objects in his photographs. Production artists at the printer, usually in a large city in the north or Midwest, added the colors by hand. In this particular case, they made the background look like night and added a moon in the sky and a caption about moonlight bathing. The card was made for John W. Plummer to sell in his store on the boardwalk. (Photograph courtesy of The Louis T. Moore Collection, New Hanover Public Library.)

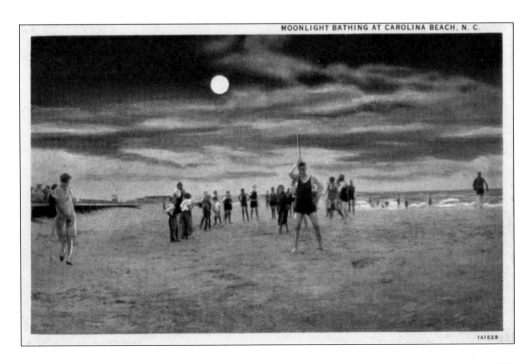

TYPICAL SCENE, ENJOYING THE SURF AT CAROLINA BEACH, N. C.,—61

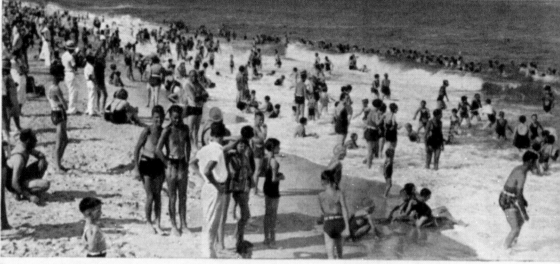

TYPICAL SCENE. On the back of this card of the beach, the caption tells of Carolina Beach's easy accessibility with fully paved roads. It wasn't always that way. In 1916, the completion of a macadamized road seven miles long was the final link between Wilmington and the beach. Macadamized roads had three layers of different size crushed stone, going from the largest on the bottom to the smallest on the top. They drained well and never turned to mud. This final link was top dressed with a layer of oil. New Hanover County paid half of the $4,500-per-mile cost. The remaining half was paid by New Hanover Transit Company, Wilmington Beach Corporation, and Kure Land and Development Company. At the time, it was the only automobile highway in North Carolina leading directly to the ocean. By 1925, it went all the way to Fort Fisher and Carolina Beach was billed as "The beach you can reach by automobile." This road and a dock fire in 1919 ended the combination steamer-railroad way of coming to the beach.

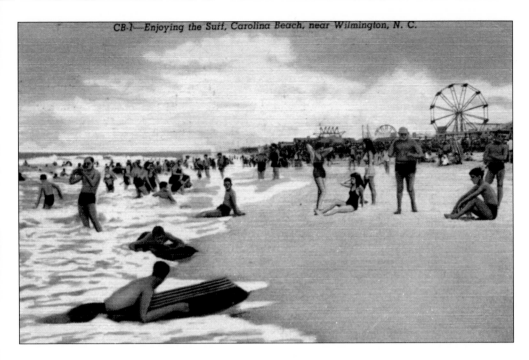

CB-1—Enjoying the Surf, Carolina Beach, near Wilmington, N. C.

Enjoying the Surf and Surf and Midway. The Ferris wheel can be seen in the backgrounds of both of these linen cards. The top one was postmarked May 18, 1951. It was sent to a lady in the Bronx, New York. The writer is a "snowbird" on her way back up north after spending the winter in Florida. She was glad to be in a cooler climate and was taking her time, expecting to be home by sometime in June. Many motorists stopped at beach towns on their way up or down Highway 17 before Interstate 95 was built and became a main north–south corridor.

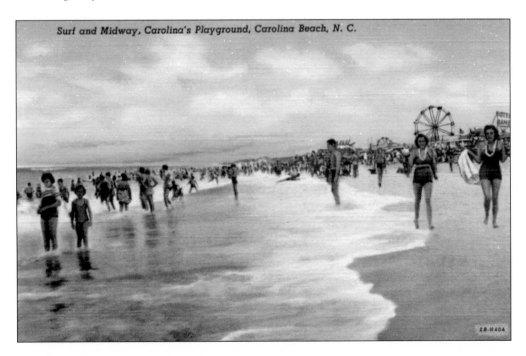

Surf and Midway, Carolina's Playground, Carolina Beach, N. C.

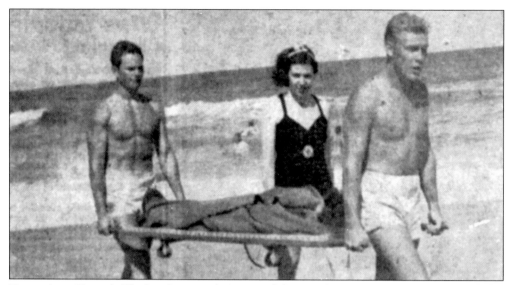

FIRST AID. Hannah Block, who was chairman of the Carolina Beach Water Safety and First Aid Committee in 1946, is shown with two lifeguards demonstrating life-saving techniques. They are carrying a stretcher case to the first aid station for treatment. The station was in town hall on the boardwalk, having been established in 1936 as the first Red Cross Highway First Aid Station in eastern North Carolina. The multitalented Block also trained lifeguards, served as one, and taught first aid to the town employees who manned the station. In the 1950s and 1960s, Lucie Fryar, a nurse and doctor's widow, served as director of the station. (Courtesy of the Bill Reaves Files, New Hanover Public Library.)

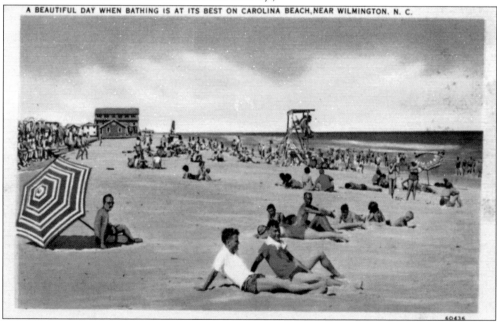

BEAUTIFUL DAY. Watson's Rooms and Apartments at 244 Carolina Beach Avenue North can be seen in the background of this card. The lifeguards are on the stand watching the ocean crowded with bathers. At one time, some of them were paid by the bathhouses on the beach and sometimes by the hotel owners as well.

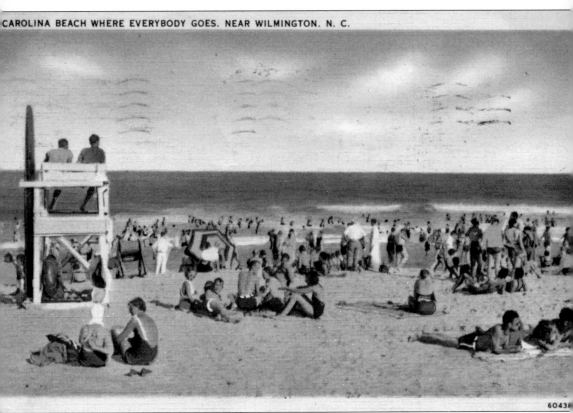

6043

WHERE EVERYBODY GOES. This lifeguard stand looks like those of today, even though the card is postmarked 1937. The writer is from Michigan and is having "a swell time." The tall, Hawaiian surfboard leaning on the left side of the guard stand was hollow but still so heavy that it took more than one lifeguard to get it in the water for a rescue.

SPREADING THE BLANKET. These girls are spreading their blanket right in front of the lifeguard stand. This area was usually dotted with blankets and young ladies hoping to catch the lifeguards' attention. The guards always placed two of the hollow torpedo buoys in front of the stand so they could grab them quickly in an emergency.

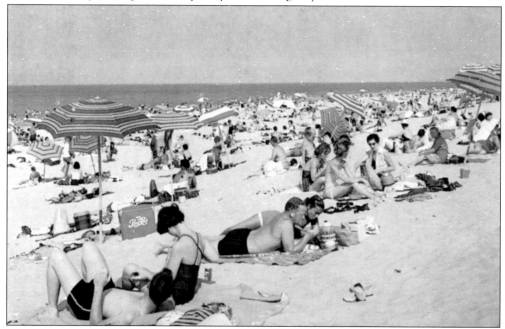

CROWDED BEACH. Hopefully there are several lifeguards on duty nearby for the crowds of beachgoers in this card postmarked 1964. Beach chairs had not yet come into fashion as blankets abound as far as the eye can see. Looking closely, thermos jugs and metal coolers can be seen sitting in the sand.

Eight

BEAUTIES

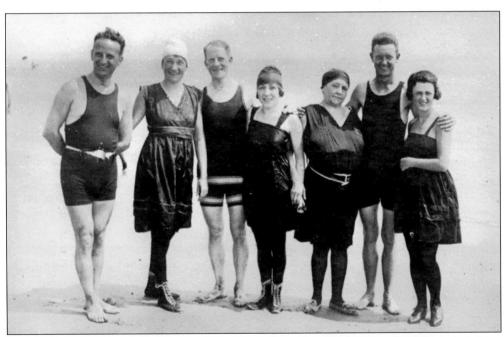

BATHERS. Smiling for the camera, this group is dressed in the height of bathing suit fashion for the early 1900s. The ladies are in knee-length dresses with stockings and laced-up boots or slippers. Sometimes the hems of their dresses were weighted so they wouldn't float up in the water. The men are in two-piece wool jersey suits with no foot attire. At Carolina Beach, this group might have later donned fancy clothes and danced the night away at the pavilion to the music of the Myers Davis Orchestra.

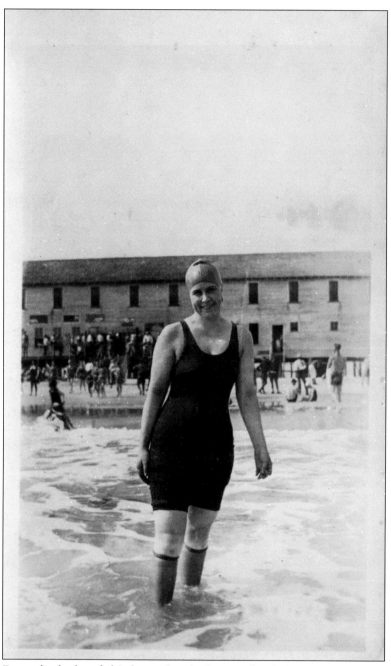

BATHER. From the looks of this beauty's suit, it must be the Roaring Twenties. Prior to that time, most women splashed and jumped in the waves, often holding onto a lifeline, but did not swim. A prevailing tenet of the day was that only men should swim. By the 1920s, women wanted to join in the sport, and their suits reflected the change. Their suits became more athletic looking, figure forming, and closely resembled the men's wool jersey tank suits. Stockings and shoes were added, along with a close-fitting bathing cap to protect the hair. These caps worked well over the popular 1920s bob and looked similar to cloche hats also worn at that time. Someone wrote "Wilmington Beach" on the back of this photograph.

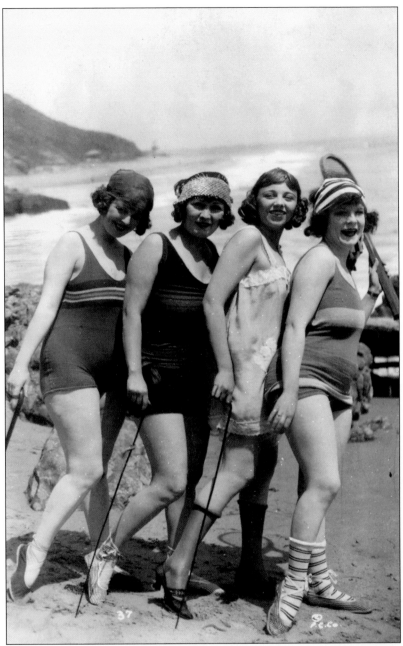

BEACH QUARTET. Like a few of the cards and images in this chapter, this photograph is not of Carolina Beach. And in this case, it is not even of the East Coast. The background certainly puts it on the West Coast and most likely in Southern California. But what a striking tableau these beauties make. Three of the ladies are wearing suits very similar to the one on the facing page, with the addition of fashionable stripes. The one on the far left appears to be a one piece and was a little daring for the time. The bather second from right is wearing a floral print dress with straps and lace trim that doesn't seem to go with the dark stockings and pumps. Her companions' footwear looks like early espadrilles. Whatever their dress, they seem very happy to be at the beach as they strike this Vaudevillian pose.

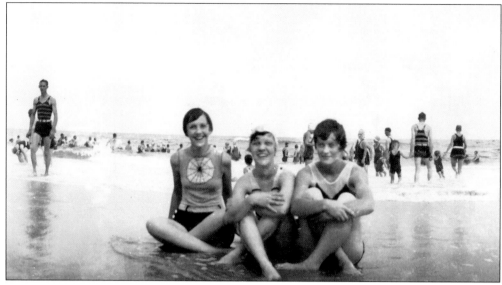

BATHING BEAUTIES. Just like the image at the top of page 105, this is a Louis T. Moore photograph taken in the 1920s or 1930s. It was also used to make the postcard at the bottom. Three young ladies sitting in the surf are the focus, but other bathers can be seen in the background, including some males. Their two-piece suits consisted of wool jersey knit tank tops and belted shorts. In 1935, the Carolina Beach Board of Alderman passed an ordinance that all males 12 and above had to wear "uppers," or shirts, with their trunks or be fined $10. In the same meeting, the board established the surf zone to be between Harper and Hamlet Avenues and passed two additional ordinances pertinent to the zone. One prohibited dogs running at large there, and the other forbid operating automobiles on the sand within the zone; both carried $10 fines. (Photograph courtesy of New Hanover County Library Louis T. Moore Collection.)

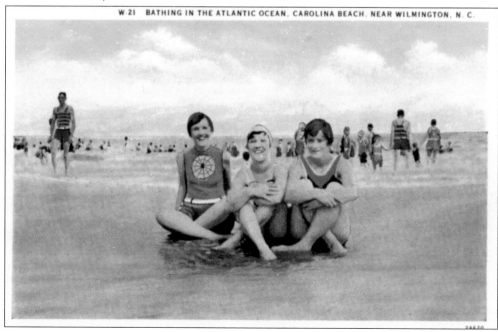

W-21 BATHING IN THE ATLANTIC OCEAN, CAROLINA BEACH, NEAR WILMINGTON, N. C.

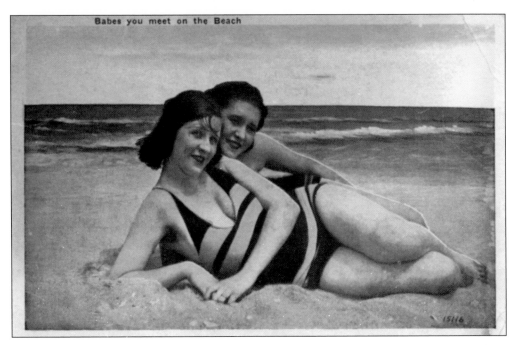

Babes you meet on the Beach

BABES YOU MEET AND A MATTER OF FORM. The babes in the card at the top were seductively lounging on the sand in wool knit bathing suits and one with a daring plunging neckline. It must have created quite a stir in 1924, when this card was postmarked. The beauty in the card at the bottom might have stirred up things too, lying on the sand and showing lots of curves in her figure-forming suit. She is also wearing a silk-tasseled scarf wrapped turban style around her head, which was very fashionable at the time.

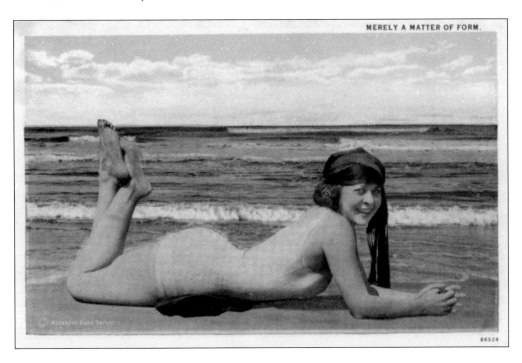

MERELY A MATTER OF FORM.

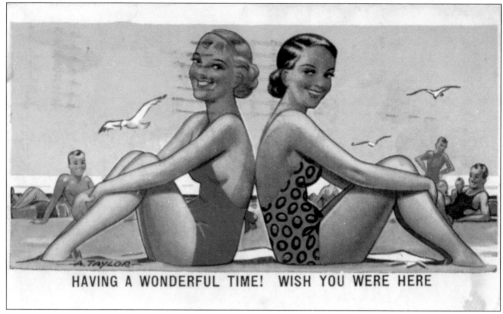

HAVING A WONDERFUL TIME! WISH YOU WERE HERE

WISH YOU WERE HERE. The cancellation stamp is across the faces of these cartoon beauties sitting on the sand in the card at the top. Their suits were somewhat revealing for 1942, when this card was mailed. They sure had a bevy of admirers in the background. The guys and girls in the card at the bottom are playing tug-of-war on the beach. Beach games were very popular and included leapfrog, as seen on the facing page, and all kinds of races. The 1946 beach season opening activities at Carolina Beach included sand castle building, swimming races, surfboard races, boat races, life-saving exhibitions, a beauty contest, and summer fashion show. The prizes were watches, diamond rings, and nylons, nylons, and more nylons. Much to the dismay of women, nylons had been a causality of the war effort and were highly prized.

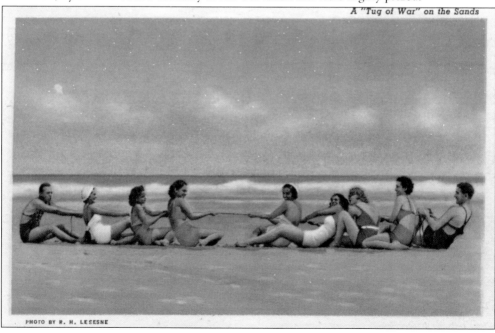

A "Tug of War" on the Sands

PHOTO BY R. H. LESESNE

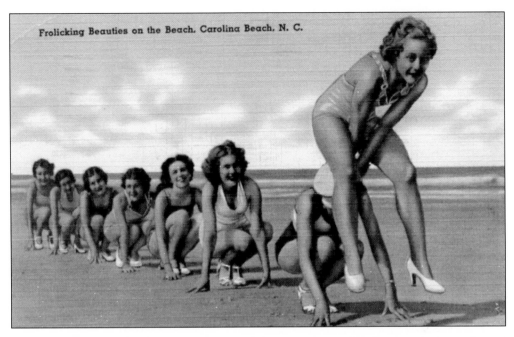

Frolicking Beauties on the Beach. Carolina Beach. N. C.

FROLICKING BEAUTIES. Playing leapfrog on the beach, these eight beauties in bathing suits and high heels illustrate the beauty contestant look that evolved in beach wear. Floyd, who wrote this card in January 1942, was probably stationed at Camp Davis and came into Wilmington for some rest and relaxation. He jokingly wrote that he had "a heavy date with the blond bomber on the front of this card." He may have come from New York state since the friend he is writing lived there. At any rate, it was freezing cold here and had actually been snowing, a common occurrence for New York but not southeastern North Carolina.

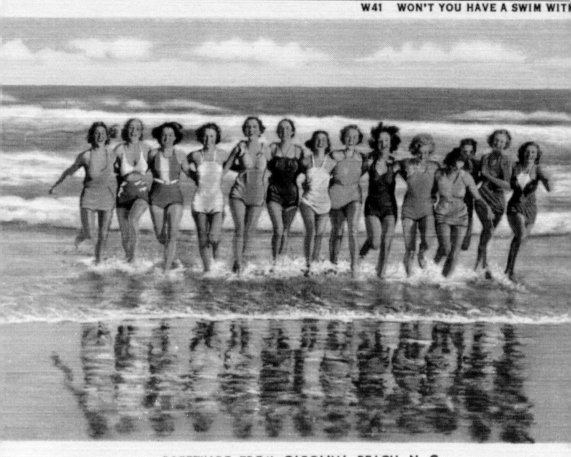

GREETINGS FROM CAROLINA BEACH, N. C.

WON'T YOU HAVE A SWIM WITH US? Some people's favorite pastime at the beach is watching the pretty girls. Who wouldn't notice a line of 14 beauties running out of the surf with their arms behind each other chorus-line style? It is a real show stopper. This card says "Carolina Beach," but this same image was used for postcards of other beach towns too.

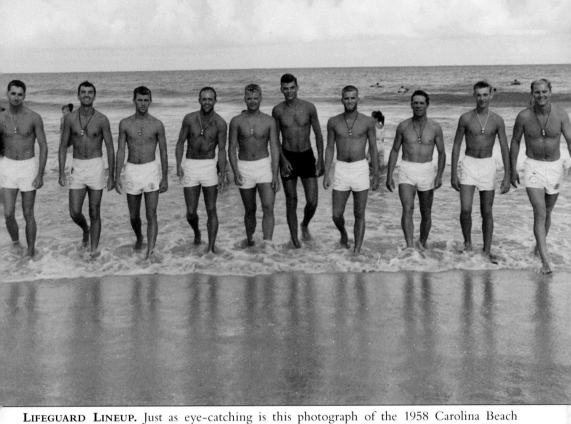

LIFEGUARD LINEUP. Just as eye-catching is this photograph of the 1958 Carolina Beach lifeguards coming out of the surf. Pictured from left to right are Ronnie Conner, Pat Allen, Grant Rogers, Bobby Sutton, head guard Tommy Greene, Dickie Wolfe, assistant head guard Byron Moore, Lanier Warwick, Boggie Myers, and Carl Lynch. When this was taken, the beach had gone for 33 years without a drowning due to the heroic efforts of these 10 guards and those who came before them. (Courtesy of Dr. Byron Moore.)

CB-12—Greetings from Carolina Beach, N. C.
"The South's Miracle Beach"

© CURT TEICH & CO., INC.

GLAMOUR GIRLS. They don't come more glamorous than the beauty lounging on the beach in the Curt Teich linen card above. With her beautifully coiffed curls, dramatic cape, halter swimsuit, white sunglasses, and platform heels, she epitomizes the word glamour. The phrase "The South's Miracle Beach" dates the card to after the 1940 fire when two blocks of the boardwalk literally rose from the ashes, being rebuilt in less than nine months for the opening of the 1941 season. Striking the same pose, the beauty in the card below is probably from the 1960s, inviting everyone to the white-sand beaches of North Carolina.

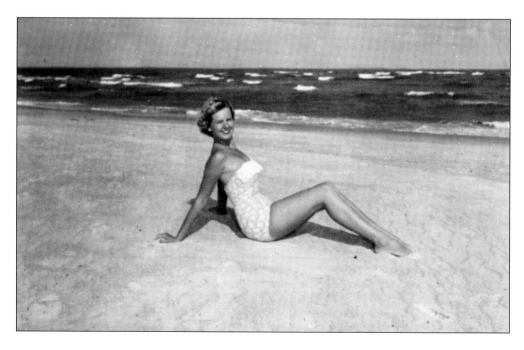

120

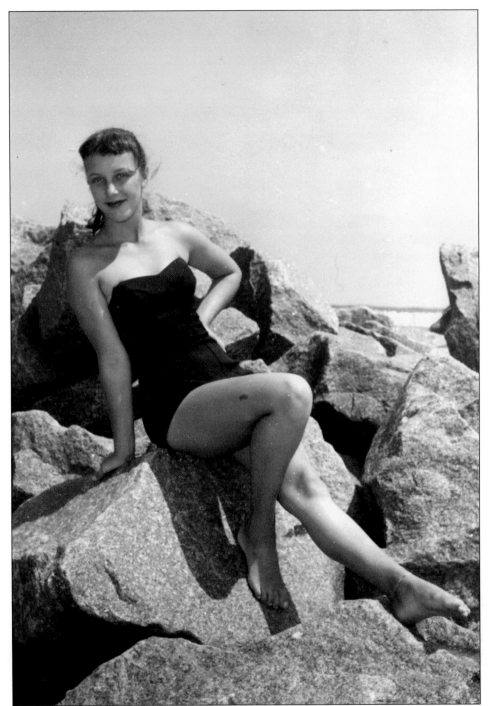

LOCAL GLAMOUR. Judy Cumber is proof positive that Carolina Beach girls were just as glamorous. She posed on a rock jetty in front of the boardwalk in 1957 for local photographer Bill Mitcham. Cumber's family owned and operated Cumber's Cottages, and she worked summer nights at Mrs. High's Dining Room waiting tables before marrying her high school sweetheart and Carolina Beach lifeguard Byron Moore. (Courtesy of Judy Cumber Moore.)

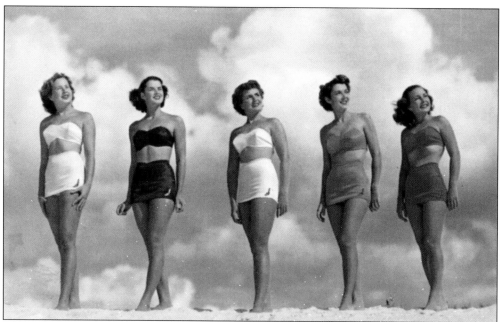

ALL LINED UP. Five 1950s beauties are lined up for the camera in this chrome card. They are wearing matching Janzen two piece suits with the classic swim girl logo. These suits were modeled after foundation garments, especially the pointed-cup top. The bottoms were cut straight across the top of the legs, girdle-like, forming a modesty apron and had a back or side zipper to ensure a snug fit. Looking in the same direction, the four Carolina Beach lifeguards at the bottom are simply wearing swim trunks with their lifeguard logo. Sitting atop the beach lifeboat are, from left to right, Lank Lancaster, Jimmy "Boggie" Meyers, Jerry Wilkins, and Coley Brown. The time was the summer of 1961. (Courtesy of Lank Lancaster.)

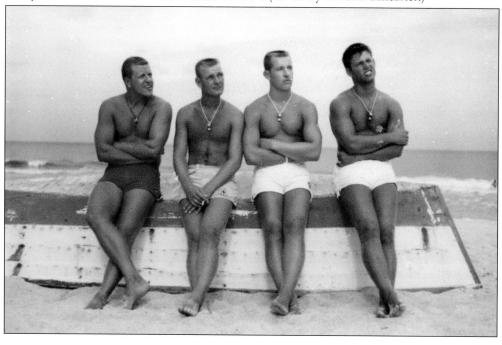

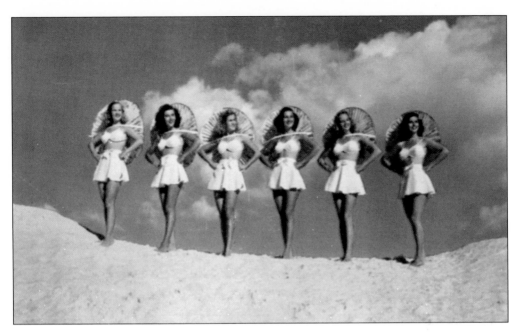

MORE LINES. During the war, the federal government actually passed legislation calling for a 10 percent reduction in the fabric content of women's swimwear. Companies complied by making midriff-bearing suits like the ones in the card at the top of this page. The tops looked like brassieres, and the bottoms were flirty skirts with bow-tied belts over matching shorts. The skirts also had the Janzen swim girl on them. It is doubtful that this fabric reduction had a measurable effect on the war effort, but the GIs certainly loved displaying pin-up images like this. The girls in the card below joined hands while they ran along the surf. The fifth girl in the lineup is wearing a playsuit, which was very popular in the 1940s and 1950s.

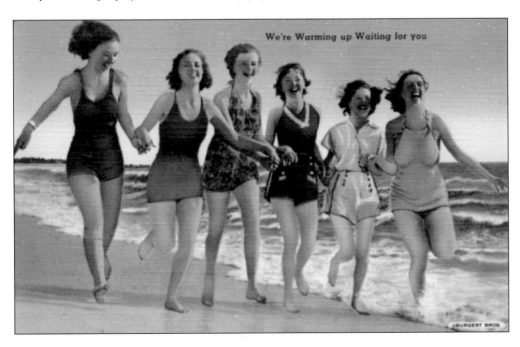

THE SURF ROLLS IN. Running out of the surf has been a constant theme of beach postcards almost since their beginning. The girls in this card from the 1950s are wearing suits made like foundation undergarments with tummy control panels, boning, and bra cups. Their male friends are in the slim-legged shorts that evolved at the same time. Men who wanted a suit less form fitting opted for loser boxer styles.

GOLDEN GIRLS. Best friends, from left to right, Susan Hickman, Mary Kathryn Turner, Elaine Henson, Karen Neuwirth, and Janet Evans pose in the surf at Carolina Beach in the summer of 2004. The girls wanted a beach shot to e-mail to Susan's husband, who was serving in the Iraq War at the time. Weary of the desert and harsh conditions there, he longed to see images from home, especially ones that included his wife.

MARY IN THE MOON. During World War II, this little girl named Mary and her mother came to Carolina Beach on a visit with Mary's father, who was stationed at Camp Davis. Since they were from the Chicago area, being at the beach was a real treat. While taking in the boardwalk amusements, Mary had her picture taken sitting in the moon. After all these years, her little ruffled top sundress, scuffed shoes, and sweet smile are simply captivating.

BIBLIOGRAPHY

Block, Frederick L. as told to Susan Taylor Block. *Tales of a Shirtmaker: A Jewish Upbringing in North Carolina.* Wilmington, NC: Winoca Press, 2005.

Block, Susan Taylor. *Cape Fear Beaches.* Charleston, SC: Arcadia Publishing, 2000.

Cashman, Diane Cobb. *Cape Fear Adventure: An Illustrated History of Wilmington.* Woodland Hills, CA: Windsor Publications, 1982.

Edwards, Jennifer J. "A Color Line in the Sand: African-American Leisure and the Coastal Environment at Sea Breeze, North Carolina." Master's Thesis. University of North Carolina at Wilmington, 2003.

www.fashion-era.com/swimwear.htm

Hall, Louis Philip. *Land of the Golden River, Old Times on the Seacoast, 1527 to 1970* Volume One. Wilmington, NC: privately printed, 1975.

Hutteman, Ann Hewlett. *One Hundred Golden Summers: A History of the Hanover Seaside Club, 1898–1998.* Wilmington, NC: Wilmington Printing Co., 1998.

———. *Wilmington, North Carolina: A Postcard History.* Charleston, SC: Arcadia Publishing, 2000.

Jones, Susie Burnett. *When the Moon Stood Still: Memories of Growing Up in Eastern North Carolina.* Raleigh, NC: Casablanca Associates, Ltd., 2003.

Kernon, Charles R. *Rails to Weeds: Searching Out the Ghost Railroads Around Wilmington.* Wilmington, NC: privately printed, 1899 and 1995.

Lasley, R. T., and Sallie Holt, editors. *Wilmington Tales.* Hickory, NC: Hometown Memories, 2002.

Norris, Daniel Ray. *Carolina Beach, NC: Images and Icons of a Bygone Era.* Carolina Beach, NC: Slapdash Publishing, 2006.

Reaves, Bill. The Bill Reaves Collection. North Carolina Room, New Hanover Public Library, Wilmington.

Robertson, Robin C. "Island Voices: Personal Memories of Carolina Beach Preserve The Past. " Master's Thesis. University of North Carolina at Wilmington, 2005.

Tetterton, Beverly. *Wilmington: Lost But Not Forgotten.* Wilmington, NC: Dram Tree Books, 2005.

INDEX

Discover Thousands of Local History Books
Featuring Millions of Vintage Images

Arcadia Publishing, the leading local history publisher in the United States, is committed to making history accessible and meaningful through publishing books that celebrate and preserve the heritage of America's people and places.

Find more books like this at
www.arcadiapublishing.com

Search for your hometown history, your old stomping grounds, and even your favorite sports team.

Consistent with our mission to preserve history on a local level, this book was printed in South Carolina on American-made paper and manufactured entirely in the United States. Products carrying the accredited Forest Stewardship Council (FSC) label are printed on 100 percent FSC-certified paper.

MADE IN THE USA